D0119614

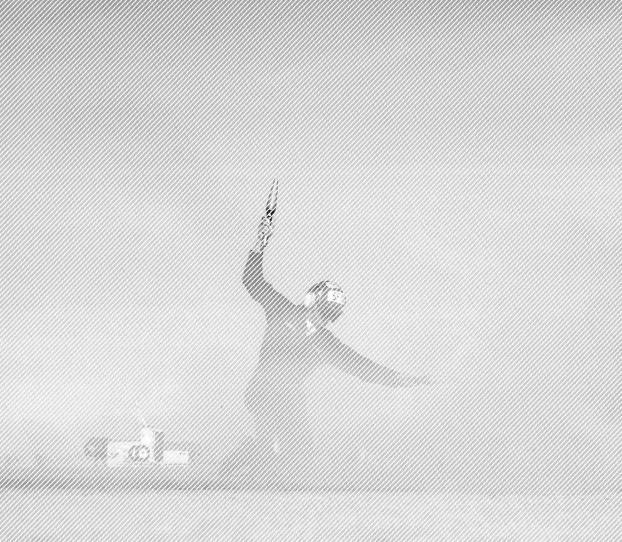

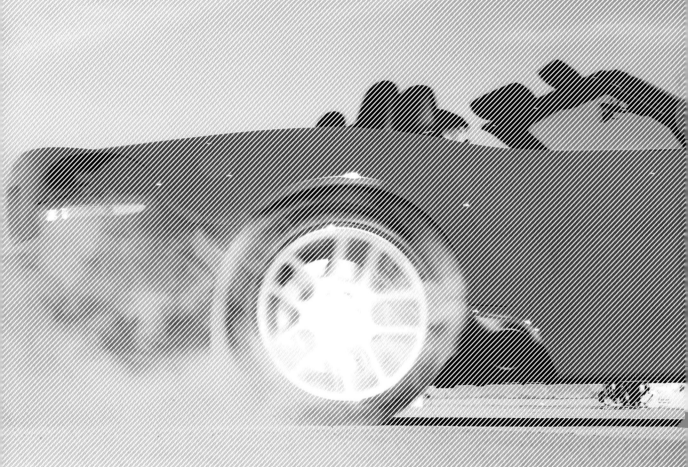

TopGear portfolio

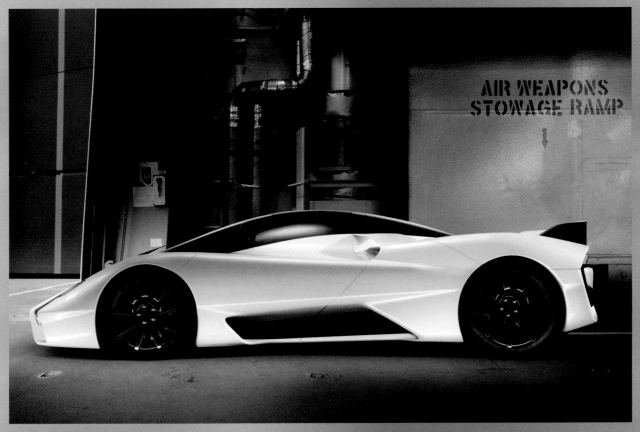

AIR WEAPONS
STOWAGE RAMP

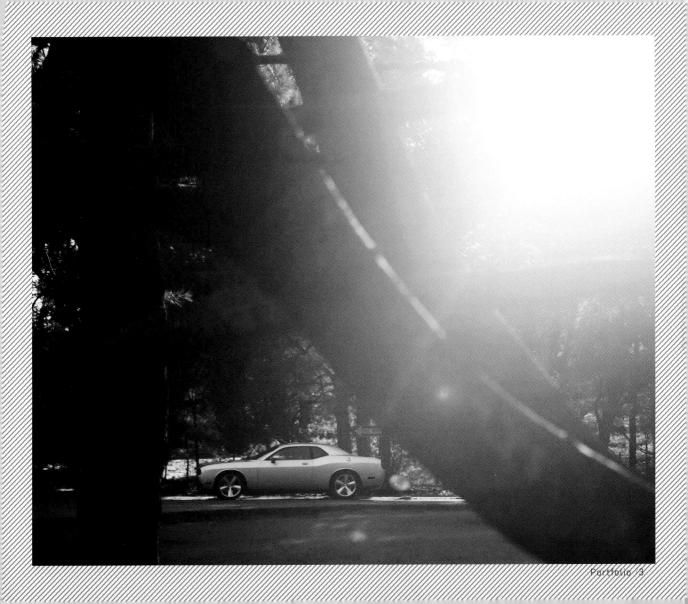

TopGear portfolio

The world's greatest cars

BBC BOOKS

Contents

Introduction

Sit back, relax and enjoy a truly epic journey to some of the world's great locations in some of the world's greatest cars.

There are worse jobs, we'll grant you, but travelling the world, photographing the fastest, most desirable cars in existence turns up its own curious set of demands. Standing around in sub-zero temperatures one day, before wilting in 40-degree desert heat the next, risking life and limb at the apex of a high-speed corner, or the constant battles with jet-lag and car sickness...

OK, so it's still a very nice way to earn a living, but we earnestly hope it provides you with as much pleasure as it does us. What you'll find in the following pages is a collection of the finest images from *Top Gear Portfolio*'s past. A sort of digitally re-mastered director's cut of what it is we get up to in producing the best car magazine there is.

There are icons of our motoring history alongside the razor's edge of groundbreaking automotive design. The best of Italian supercar exotica meets the might of American muscle and the peerless ingenuity of German engineering. We get up close to some of the most secretive projects in the industry and stand right back to take in the greatest driving roads on Planet Earth.

There are huge changes afoot for those of us with petrol in the blood. Fuel prices are sky-rocketing week on week and Johnny Sensible electric cars are pouring on to the market, so moments like the ones we've captured here are going to be perilously thin on the ground. The best of *Top Gear Portfolio* celebrates the past and the present, not just of our magazine, but of an industry at a critical point in its evolution.

From the shadow of the Great Wall of China to the whiteout of the Arctic Circle; from the lunar landscape of Area 51 to the urban jungles of Los Angeles or Tokyo, we've gone there, driven it and shot it in glorious technicolour. Take it all in, enjoy it as much as we have, and keep your fingers crossed for the future.

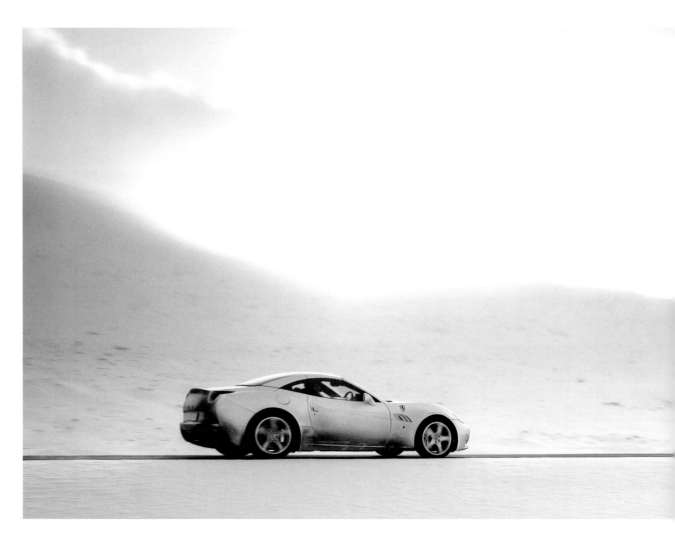

Ferrari California

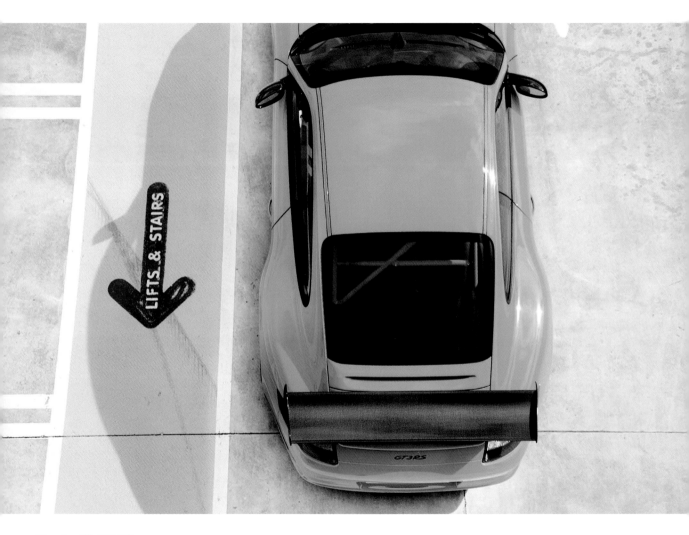

Porsche 911 GT3 RS

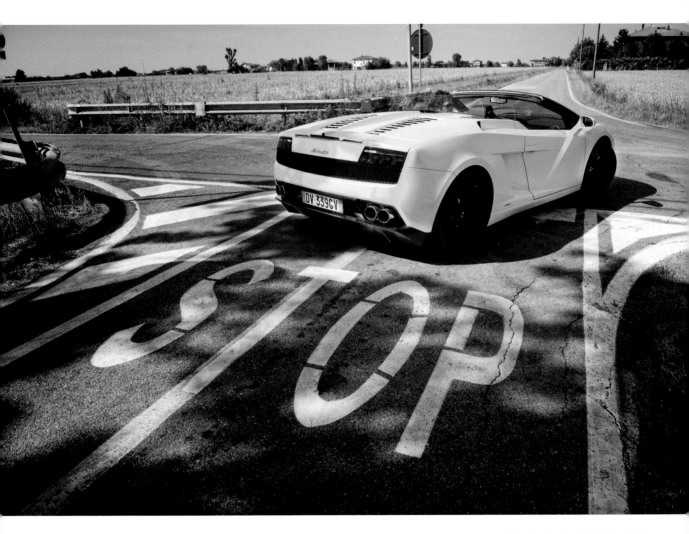

Lamborghini Gallardo Spyder

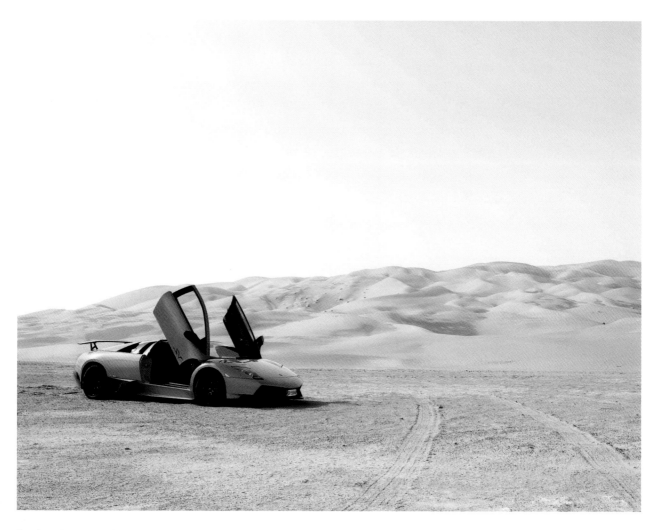

Lamborghini Murciélago SV

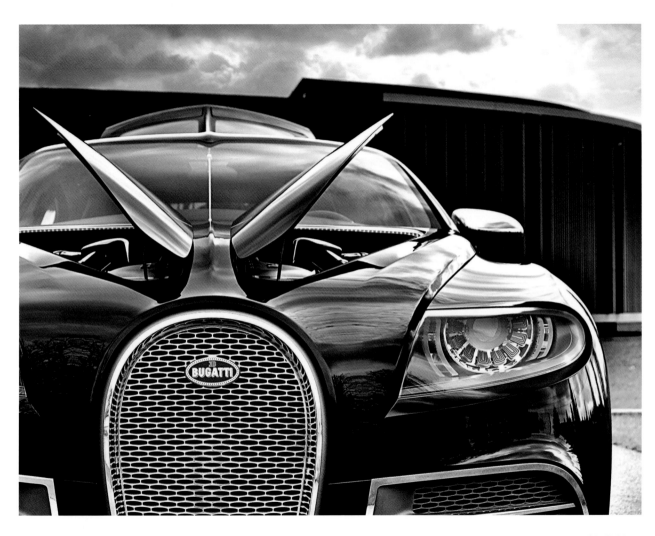

Bugatti 16C Galibier

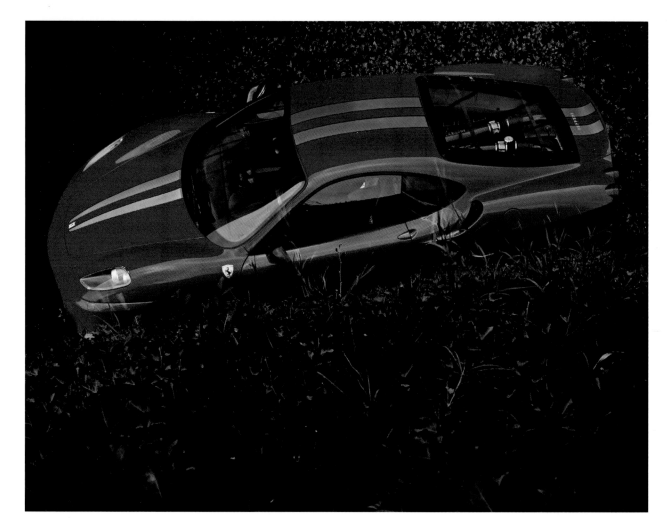

Ferrari F430 Scuderia

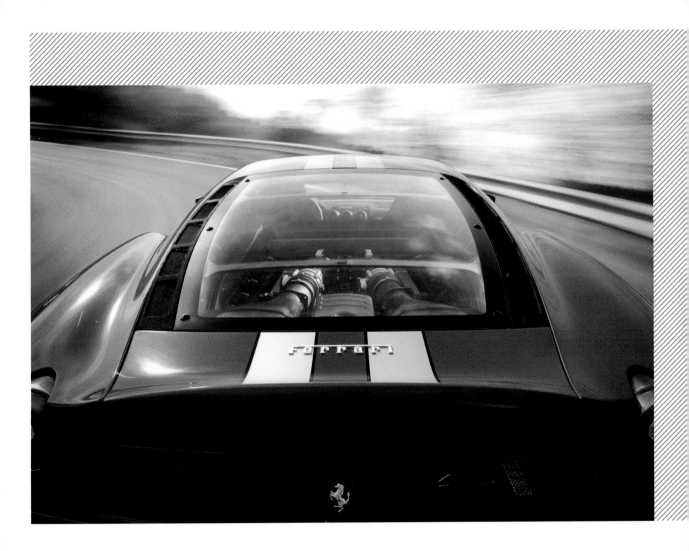

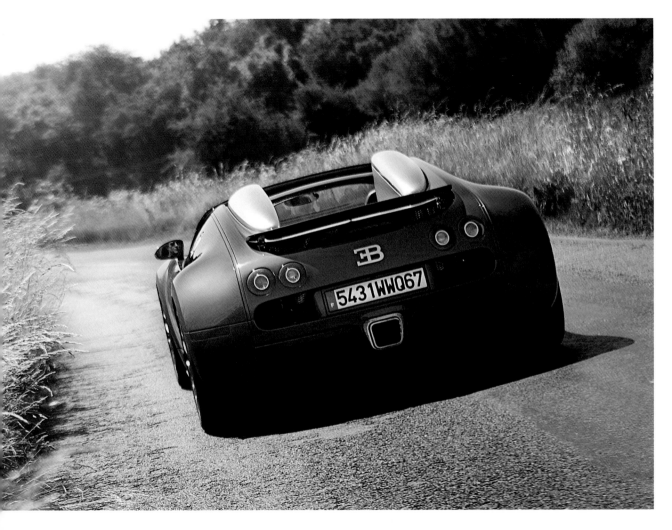

Bugatti Veyron Grand Sport

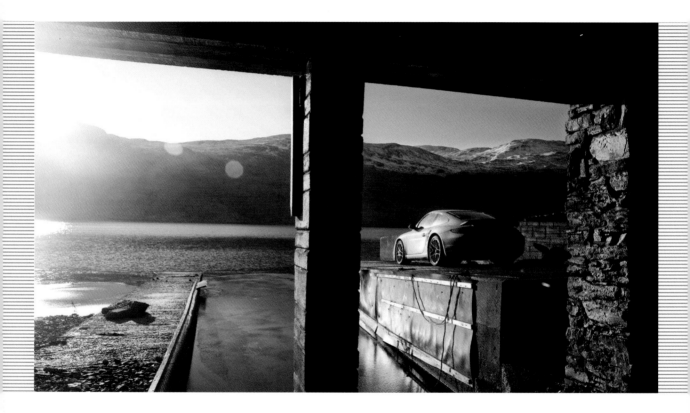

Porsche 911 Turbo

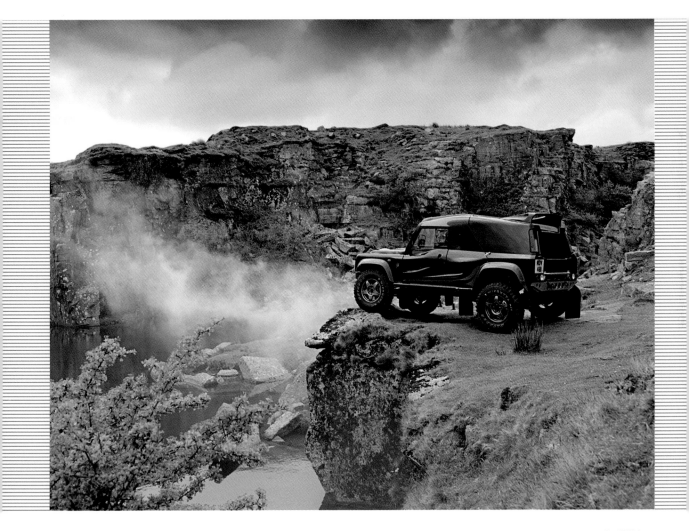

Qt Wildcat

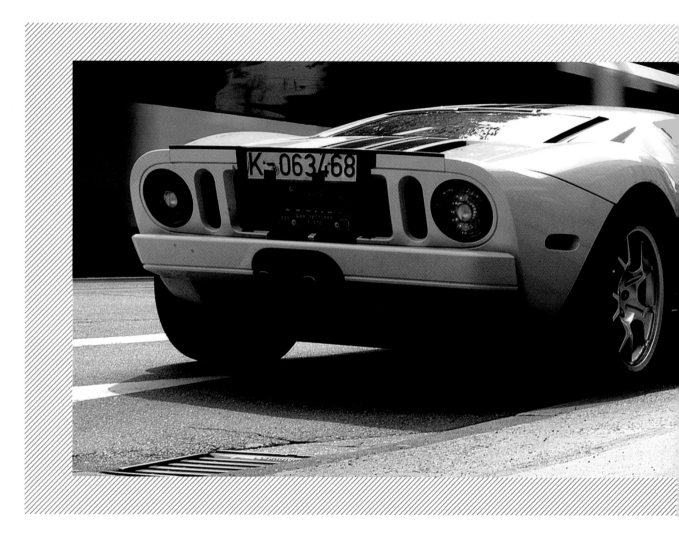

Ford GT Prototype

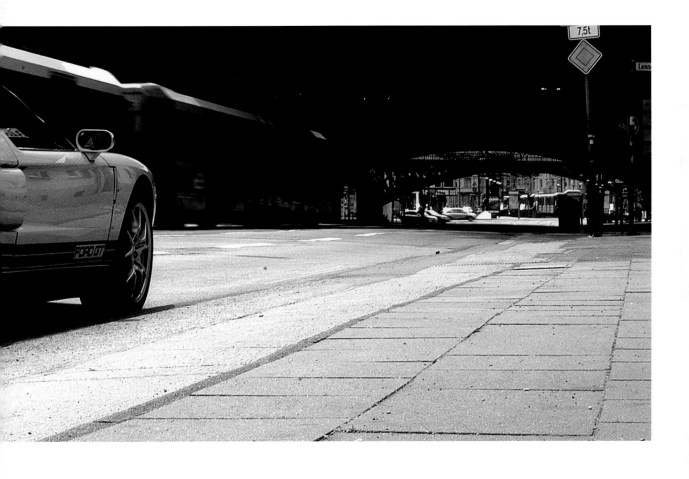

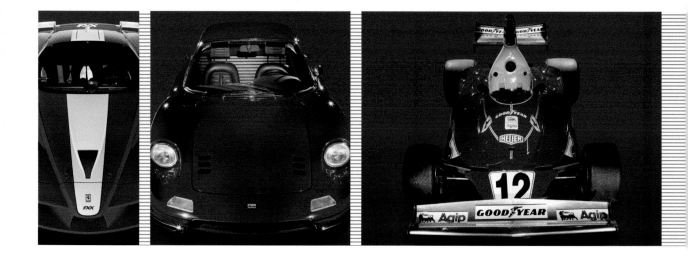

Ferrari FXX; Ferrari Dino 246; Ferrari 312 T

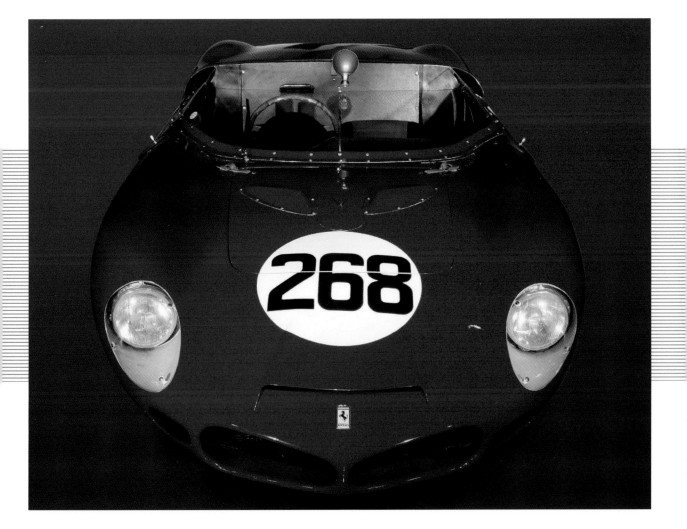

Ferrari 268 SP

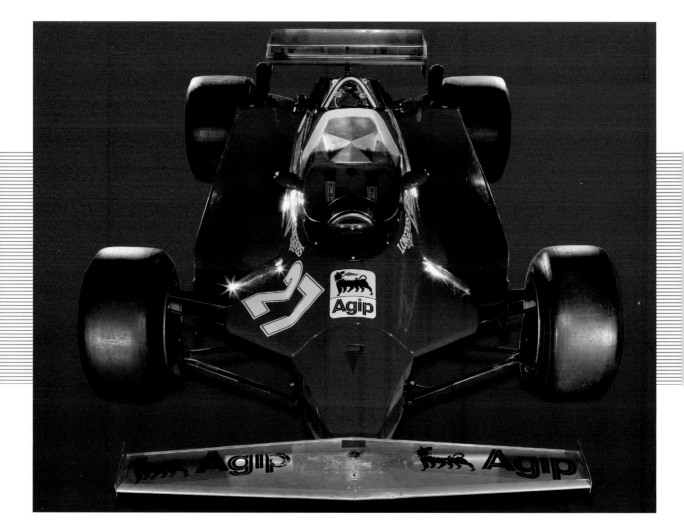

Ferrari 126 C

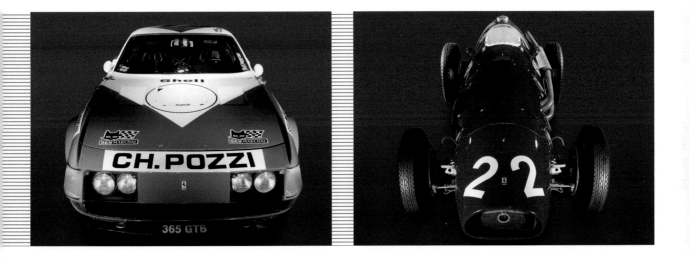

Ferrari 365 GTB/4 Competizione; Ferrari 500 F2

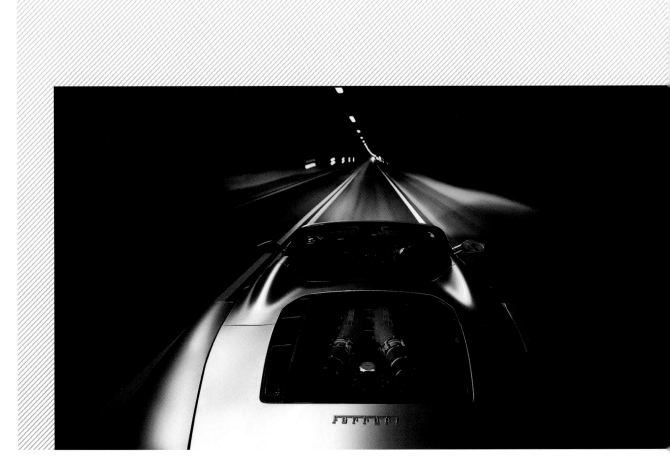

Ferrari F430 Spider

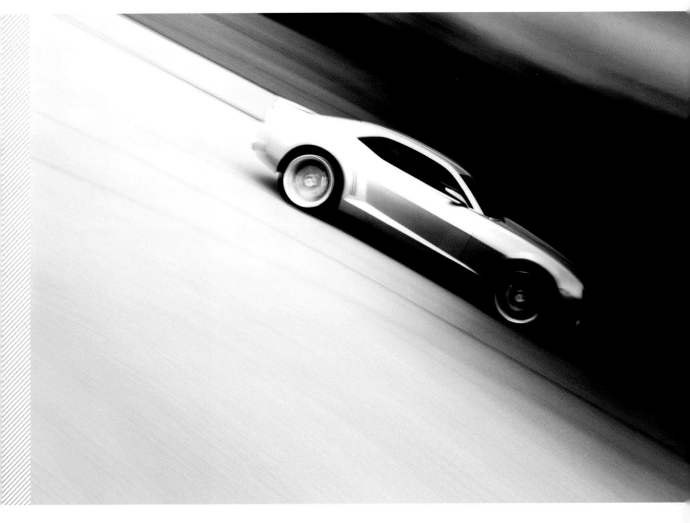

Chevrolet Camaro

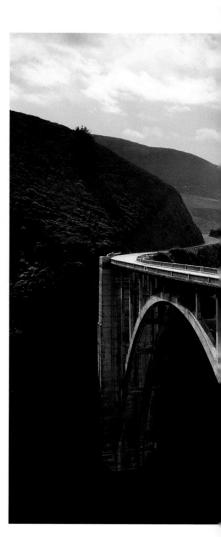

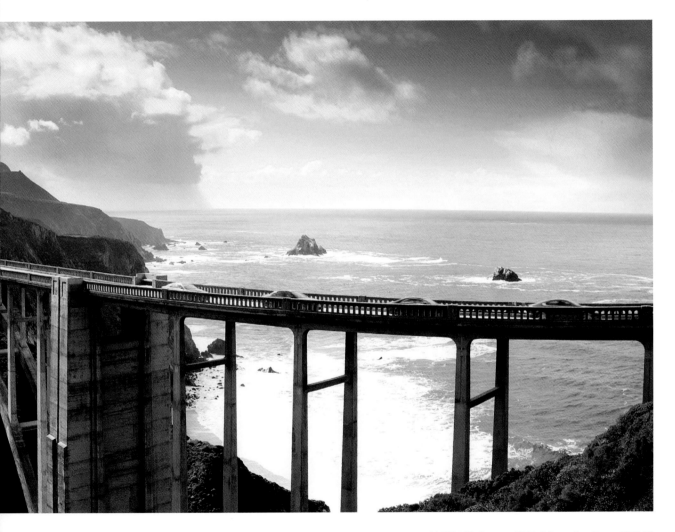

BMW M5; Jaguar XFR; Mercedes-Benz CLS 63

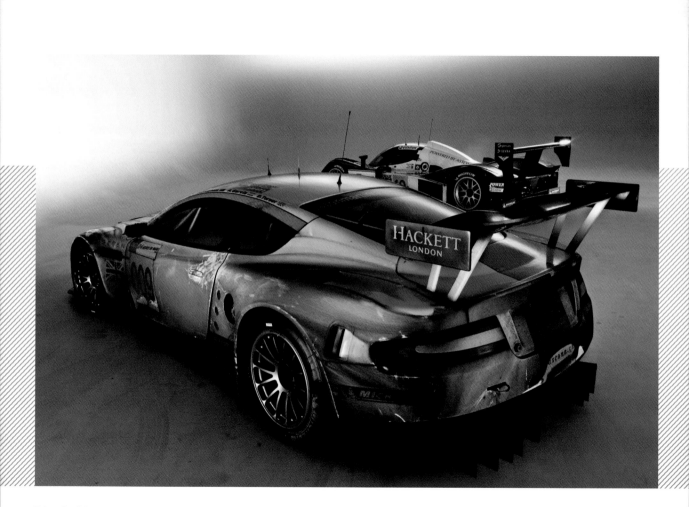

Dirty Le Mans Aston Martins

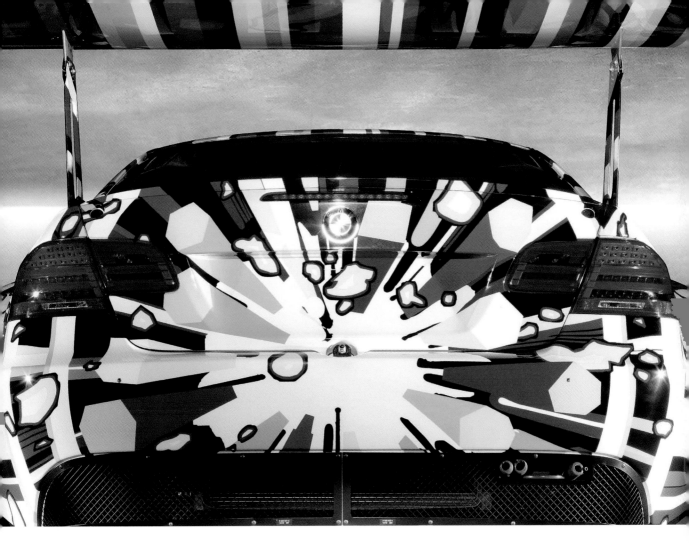

BMW M3 GT2 Art Car

Maserati GranTurismo

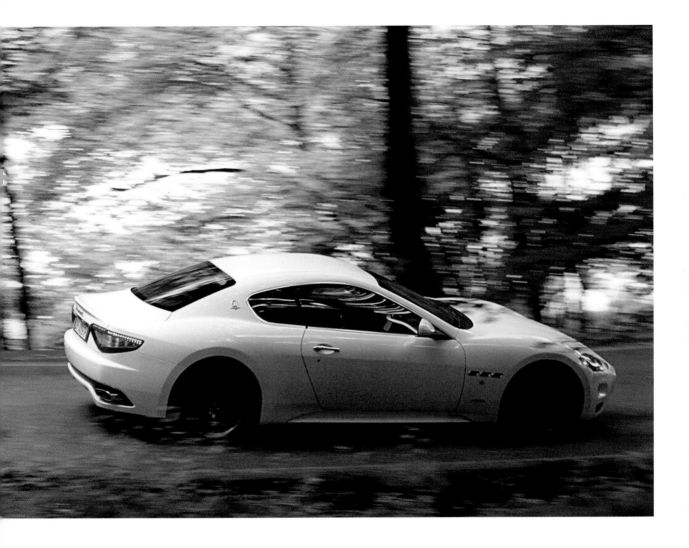

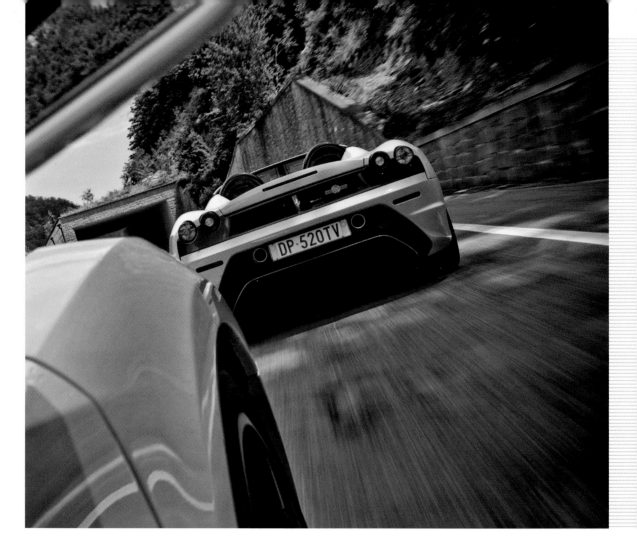

Lamborghini Gallardo Spyder; Ferrari Scuderia Spider 16M

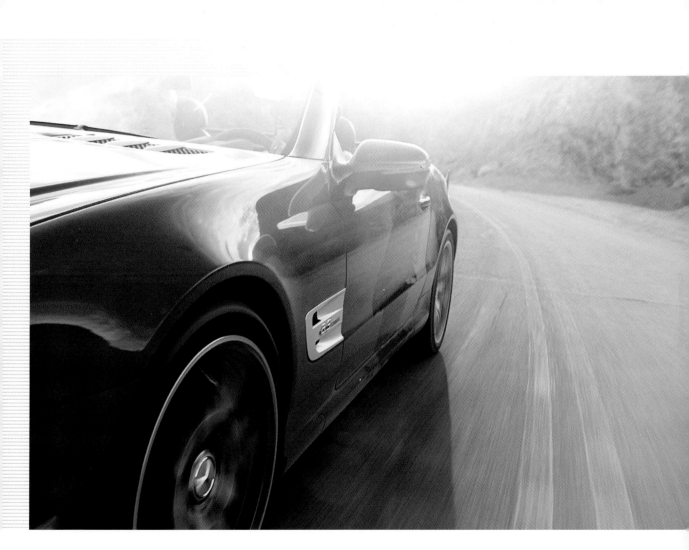

Mercedes-Benz SL 63 AMG

Ferrari 458

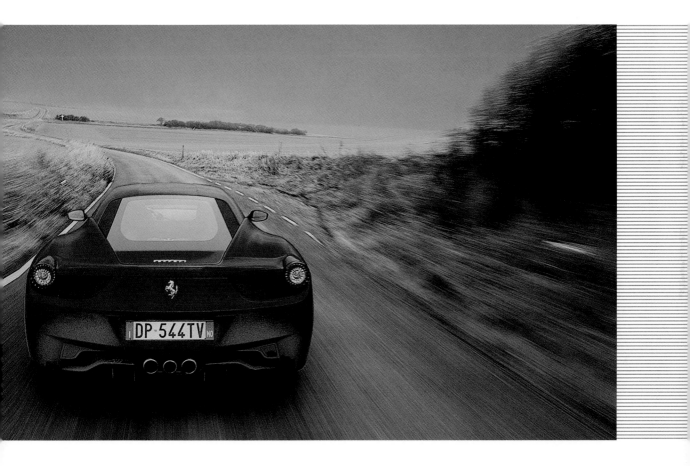

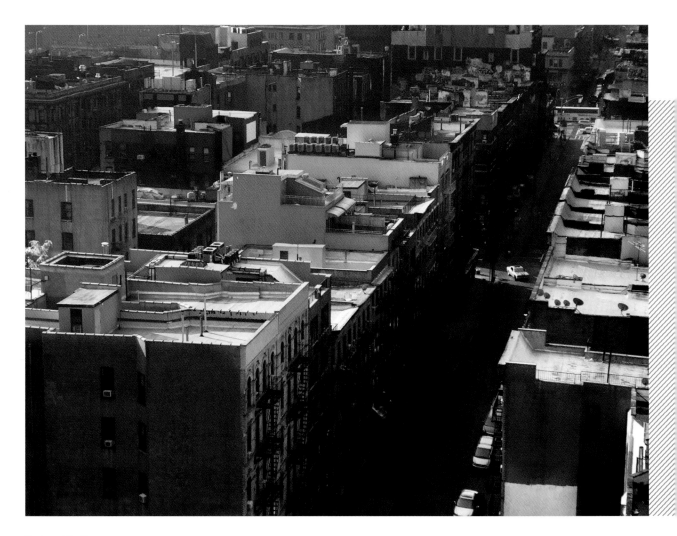

Dodge Challenger

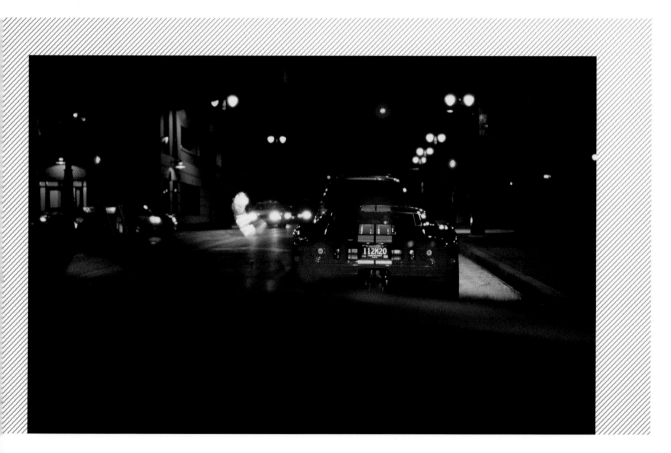

Ford GT

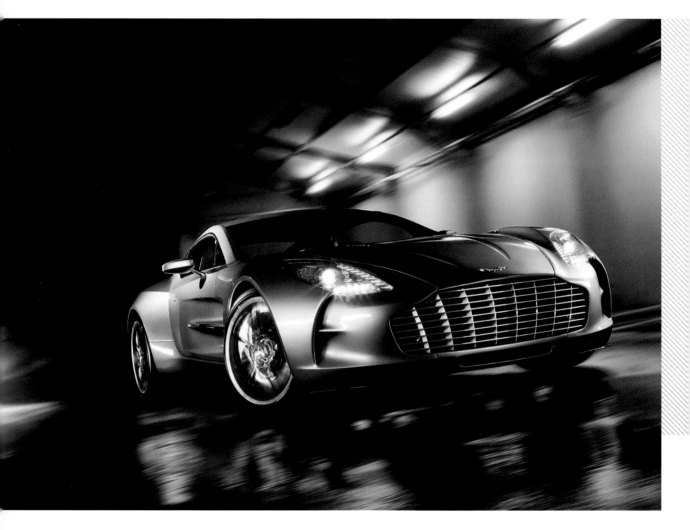

Aston Martin One-77

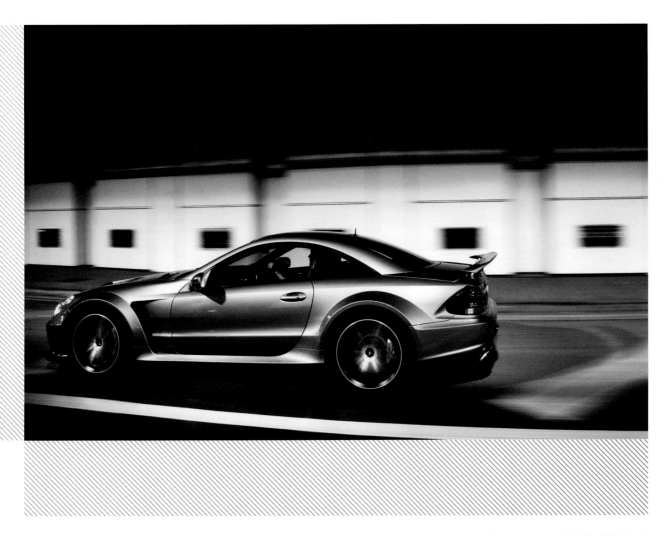

Mercedes-Benz SL 65 AMG Black

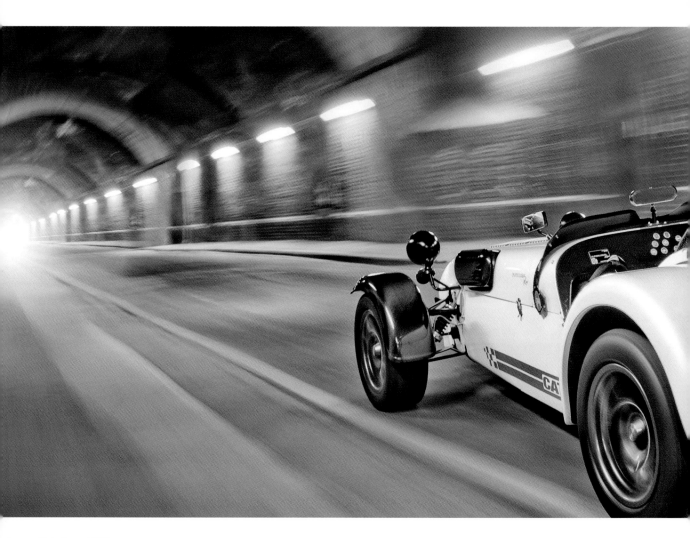

Caterham R500

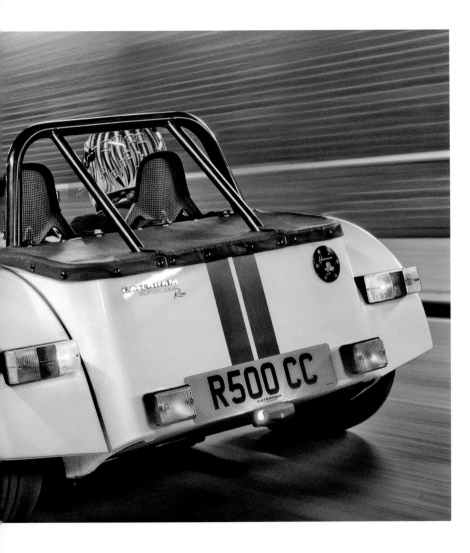

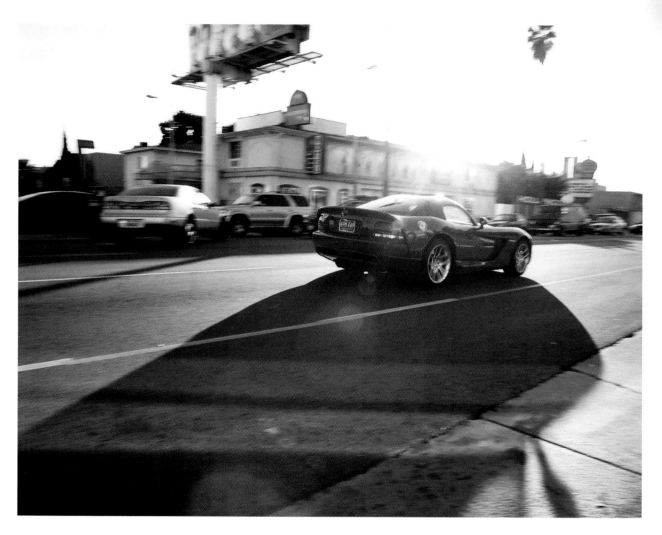

Dodge Viper

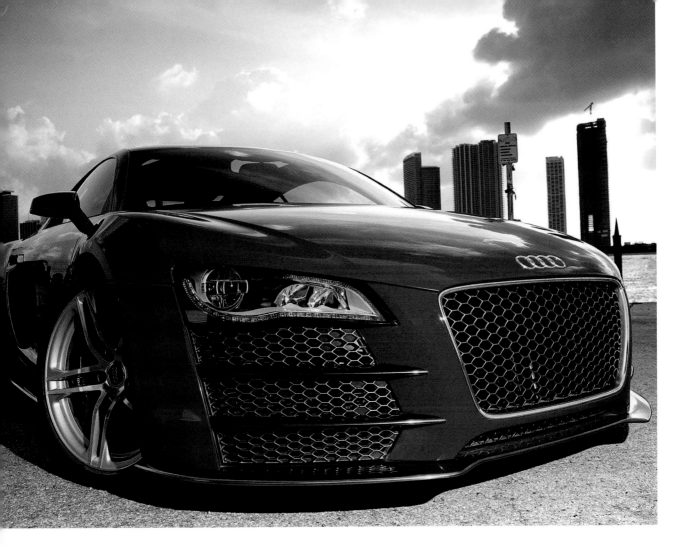

Audi R8 V12 TDI

Rolls-Royce Phantom Drophead

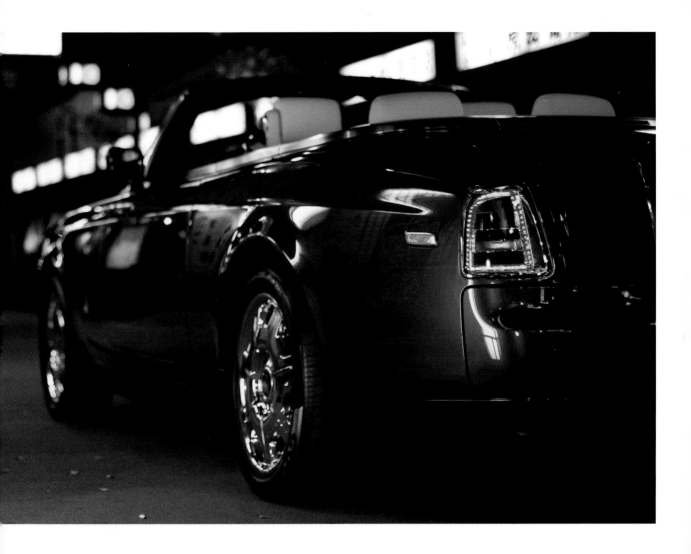

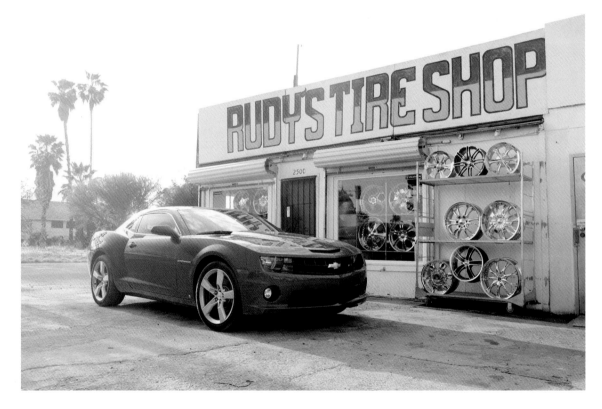

Chevrolet Camaro

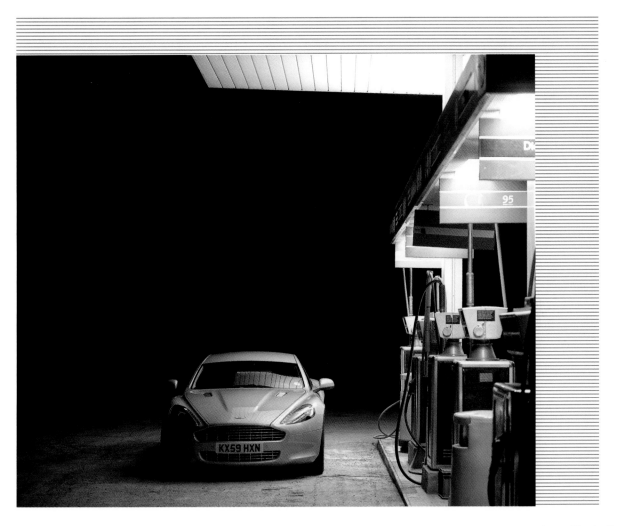

Aston Martin Rapide

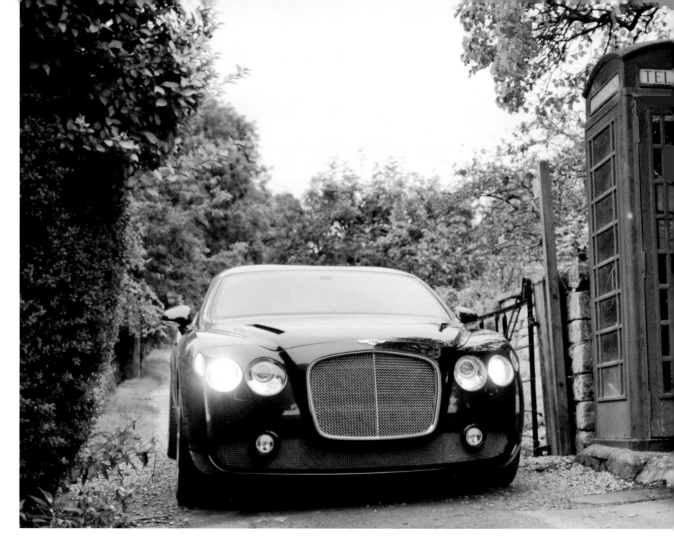

Bentley GTZ Zagato

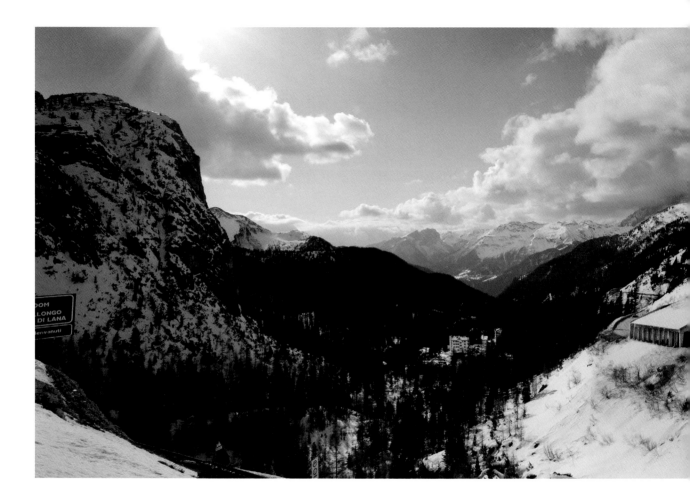

Aston Martin DBS; Ferrari 599 GTB; Lamborghini Murciélago

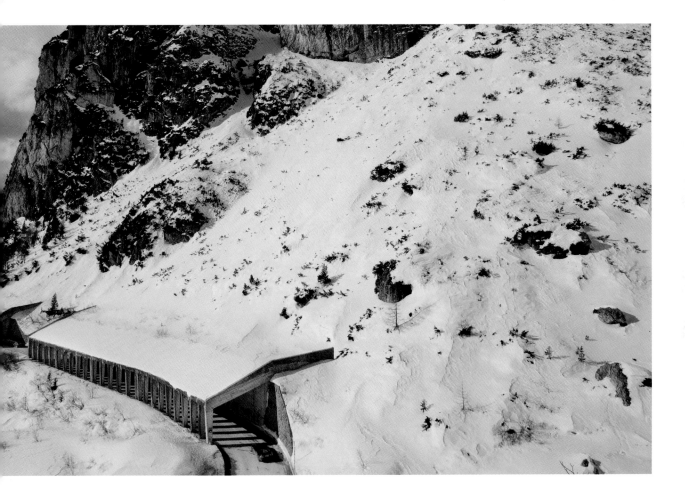

Aston Martin DBS; Lamborghini Murciélago; Ferrari 599 GTB

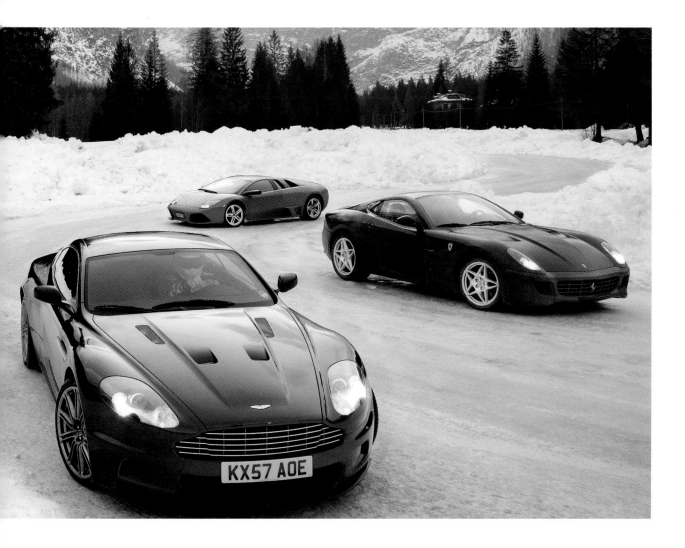

KX57 AOE

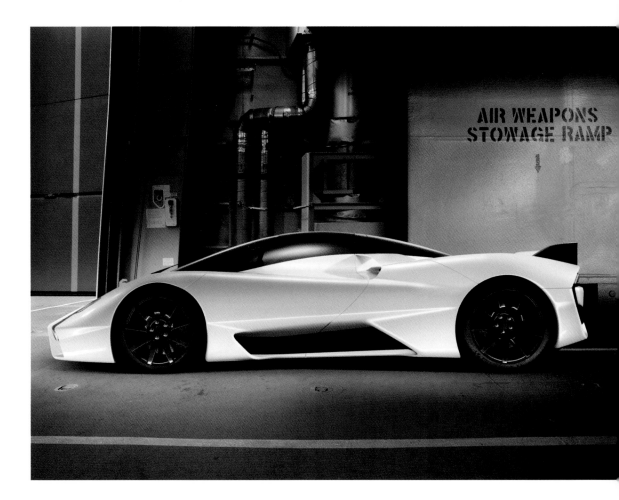

SSC

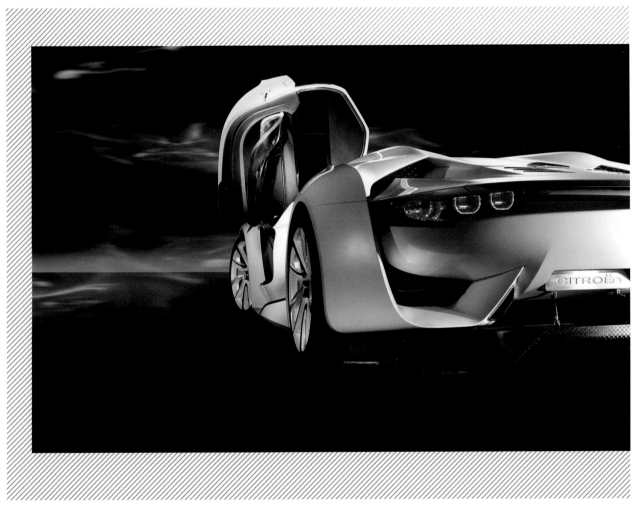

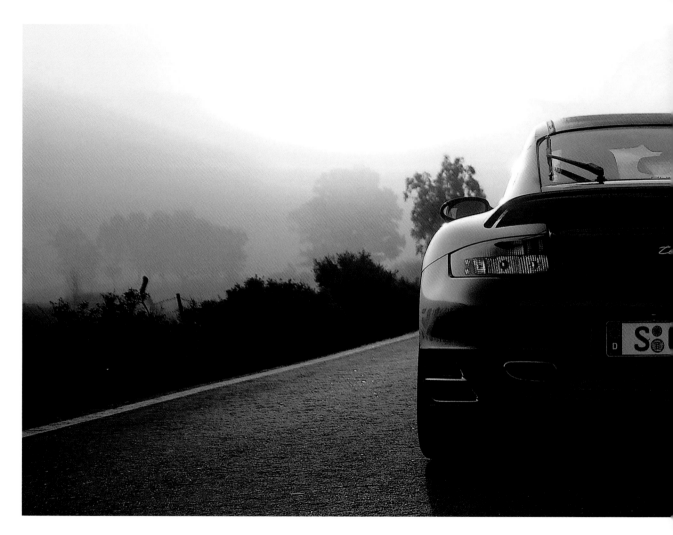

Porsche 911 Turbo

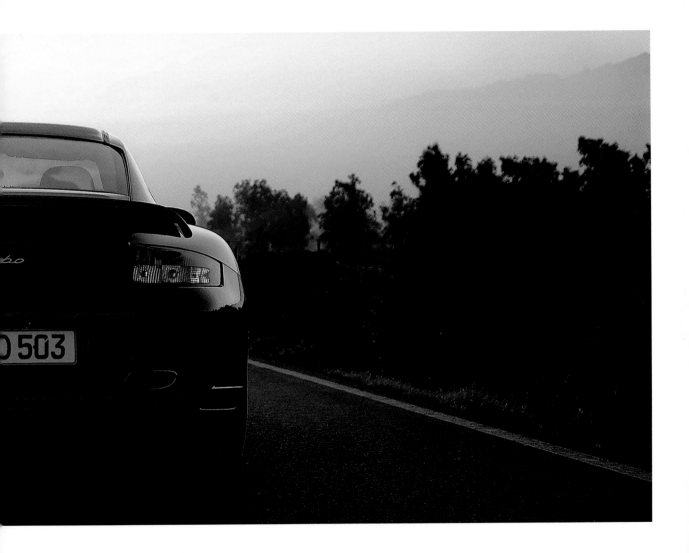

Bentley Brooklands

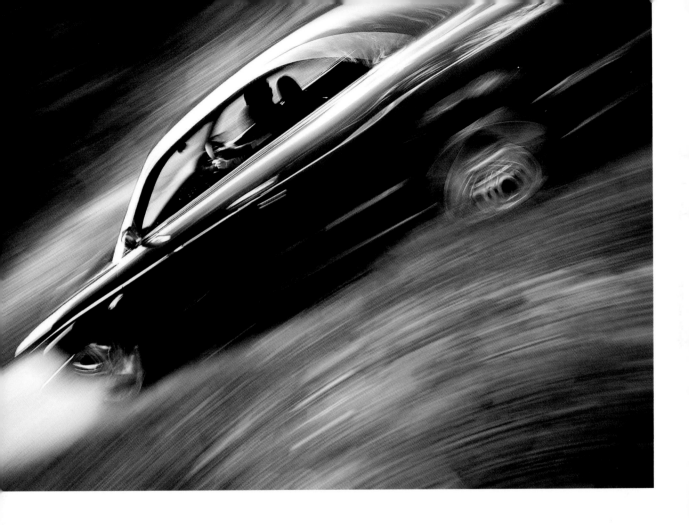

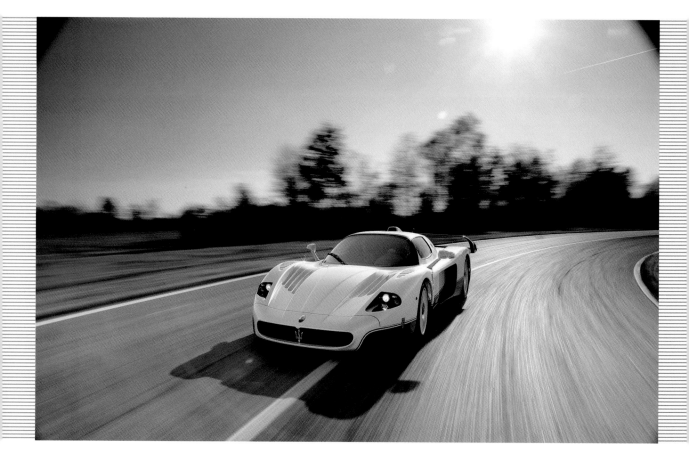

Maserati MC12

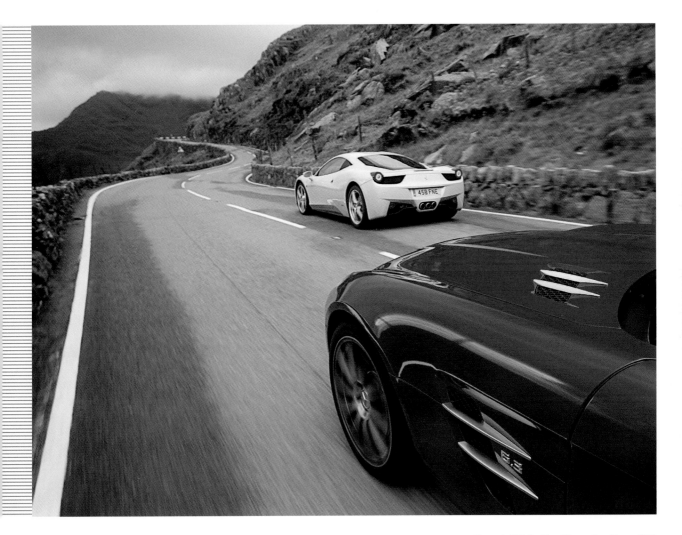

Ferrari 458 Italia; Mercedes-Benz SLS

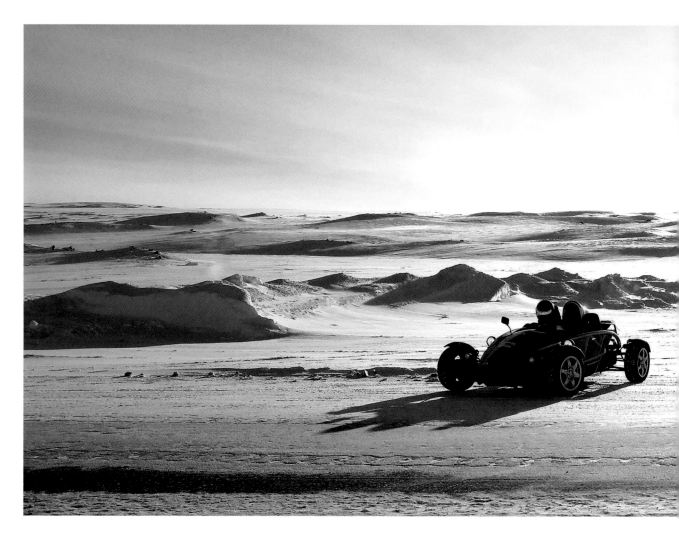

Ariel Atom

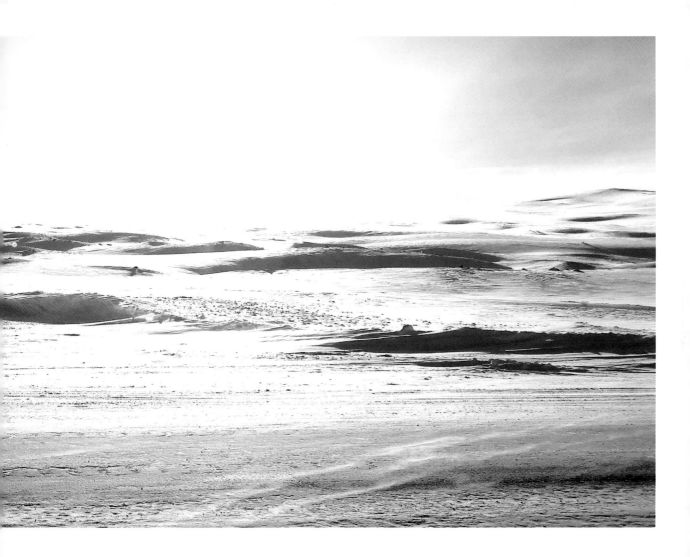

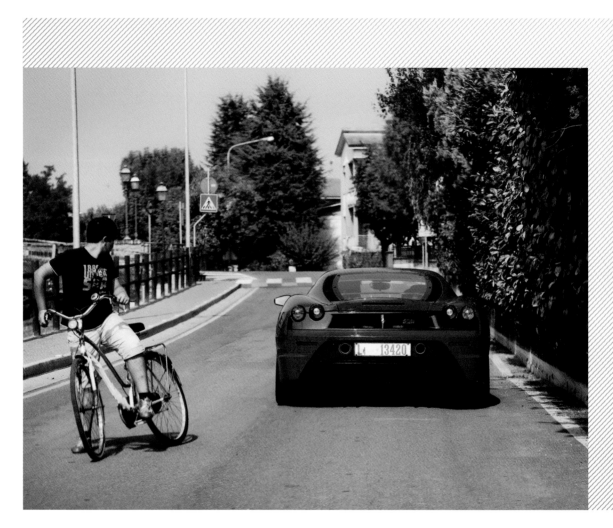

Ferrari 430 Scuderia

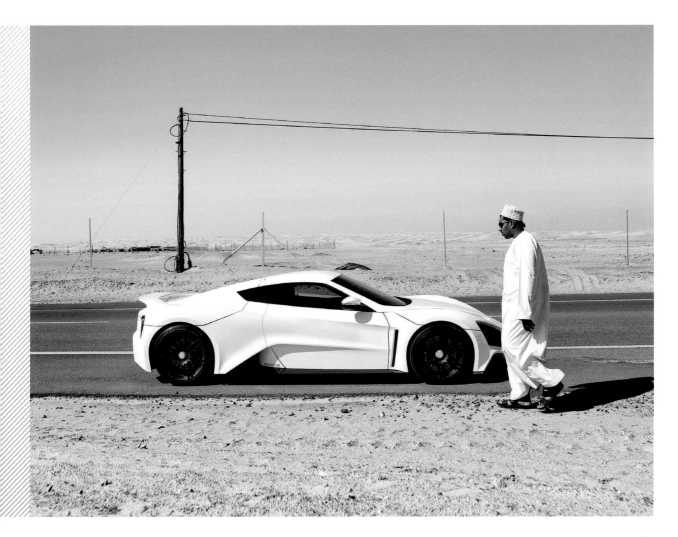

Zenvo ST1

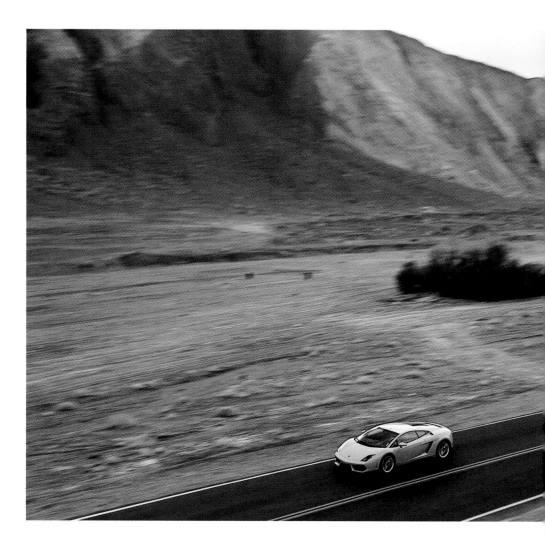

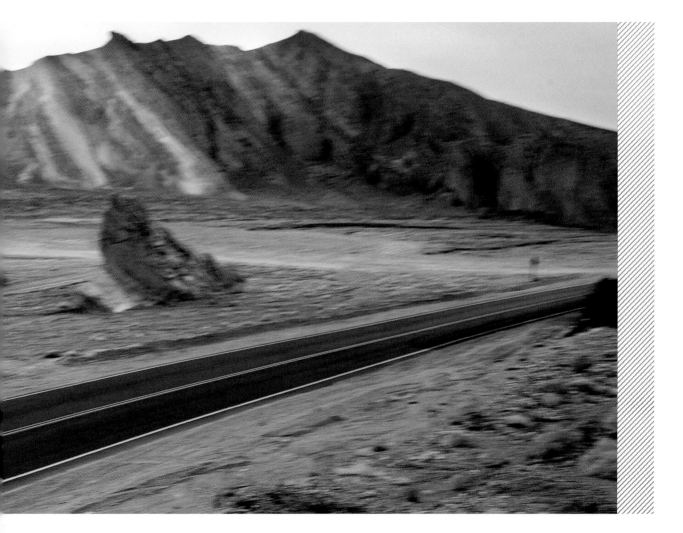

Lamborghini Gallardo LP560-4

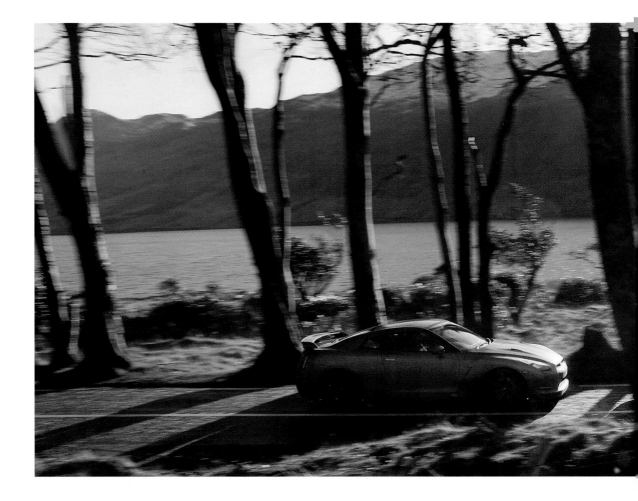

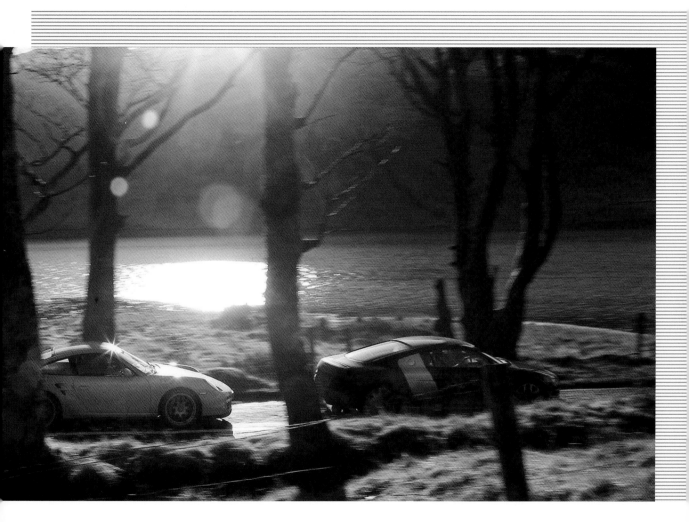

Nissan GT-R; Porsche 911 Turbo; Audi R8 V10

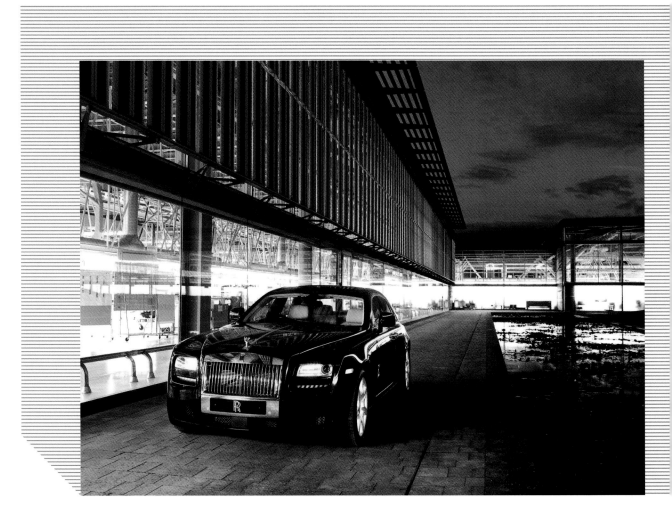

Rolls-Royce Ghost

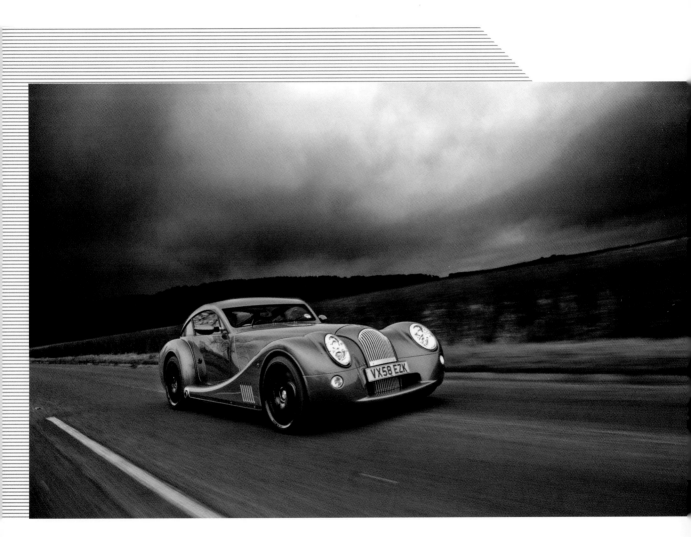

Morgan AeroMax

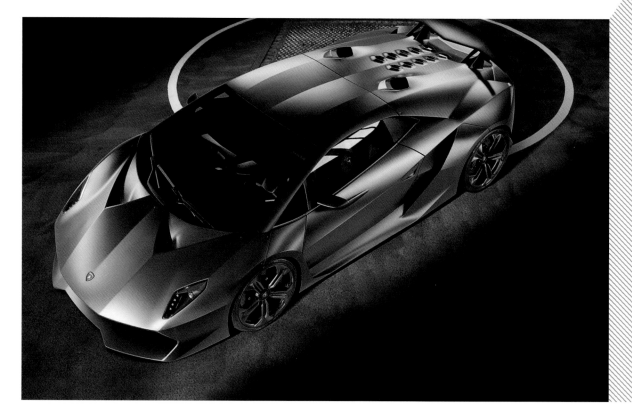

Lamborghini Sesto Elemento

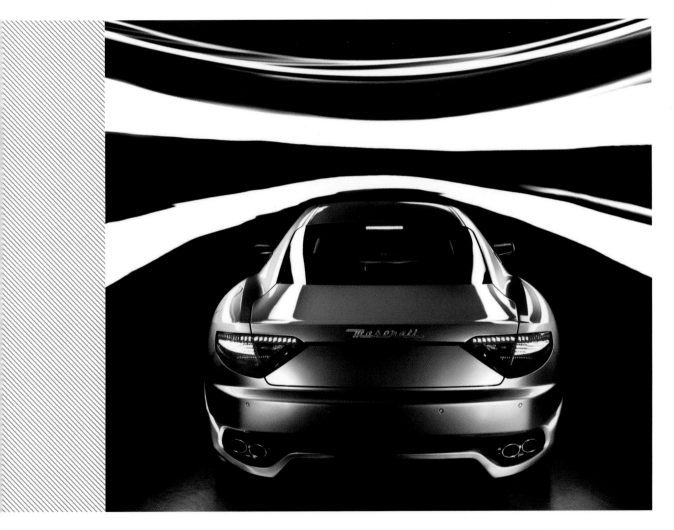

Maserati GranTurismo

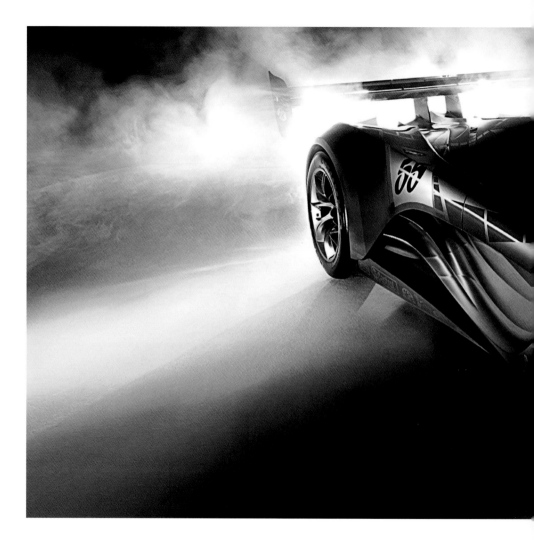

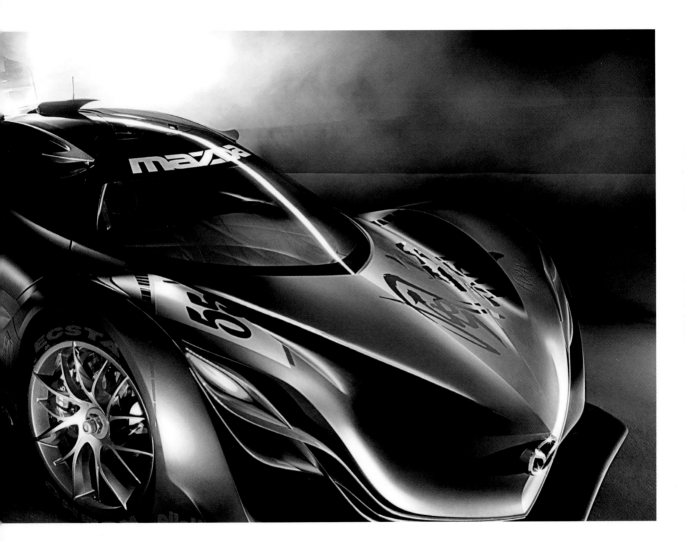

Mazda Furai

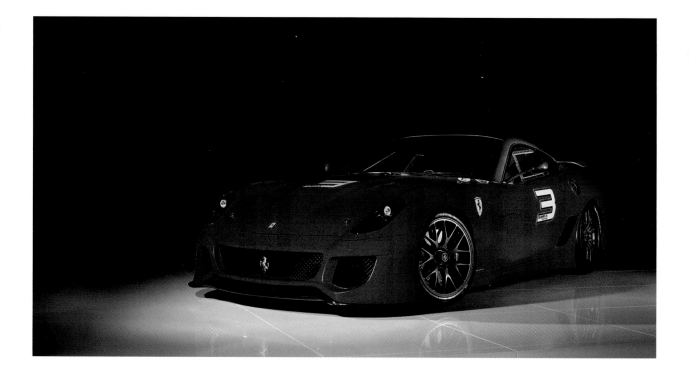

Ferrari 599XX

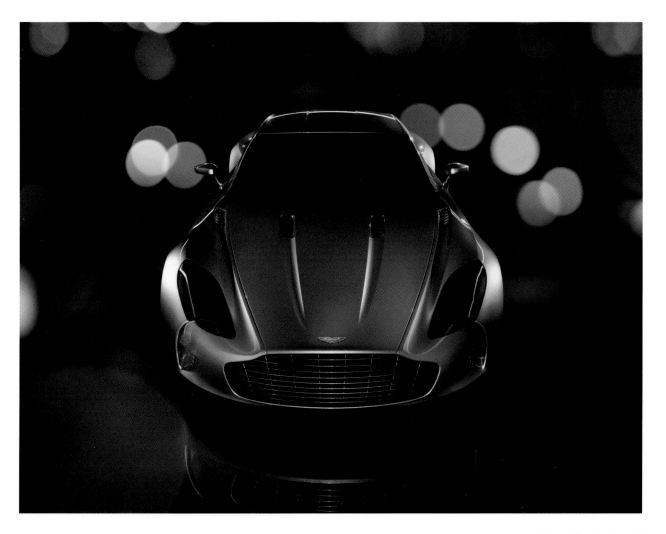

Aston Martin One-77

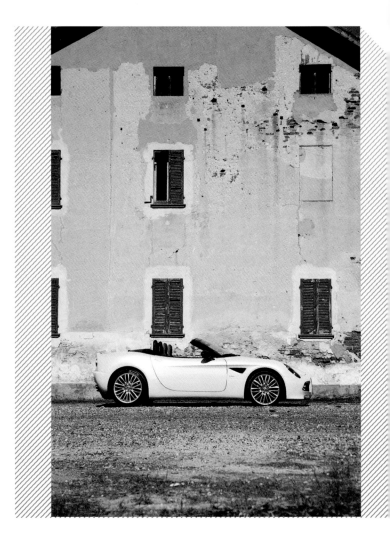

Alfa Romeo 8C Spider

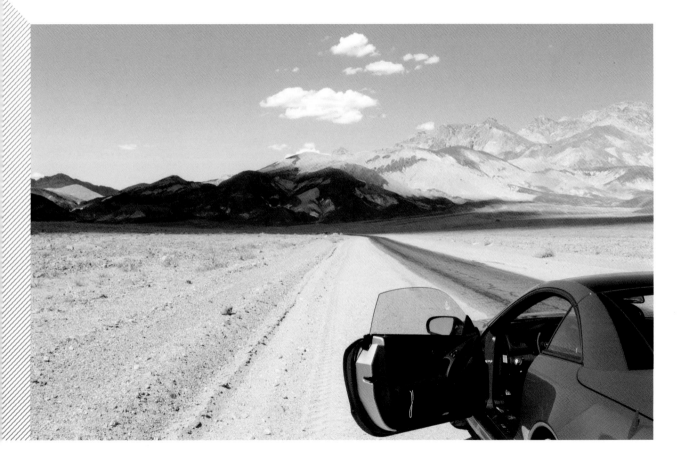

Mercedes-Benz SL 63 AMG

Noble M600

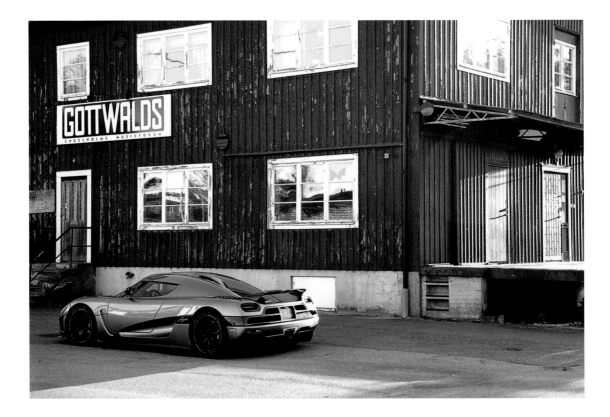

Koenigsegg Agera

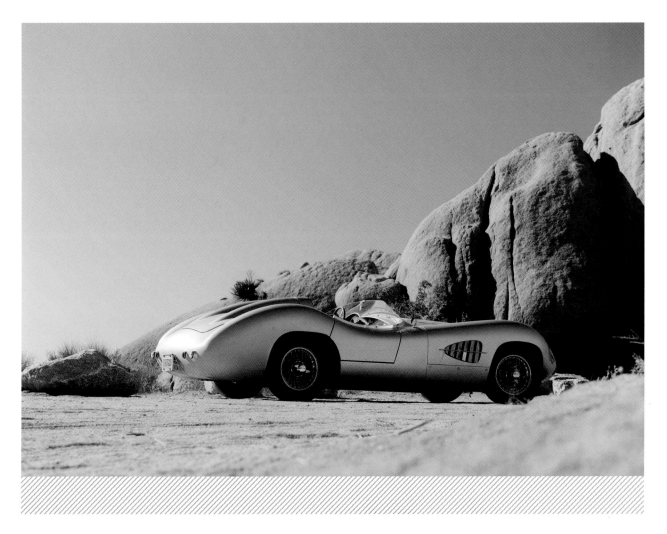

Rizk DBR2

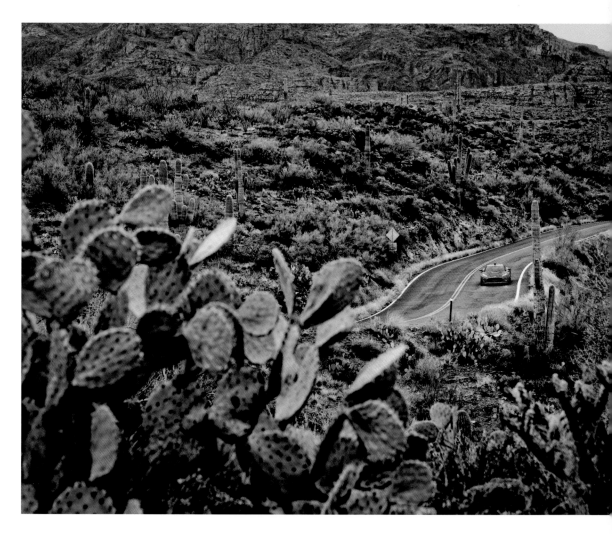

Spyker C8 Aileron

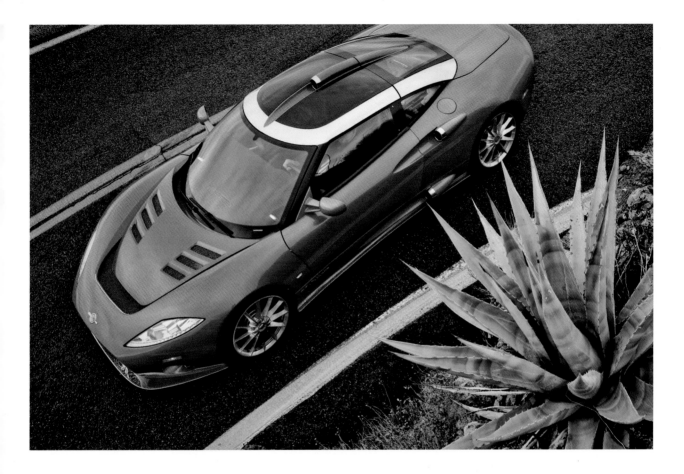

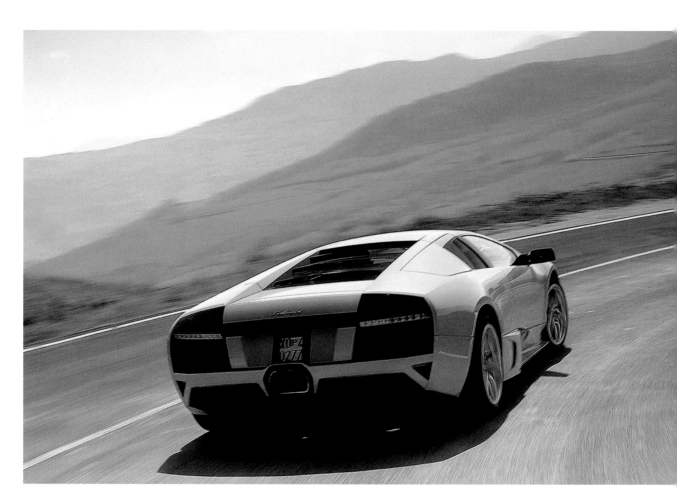

Lamborghini Murciélago

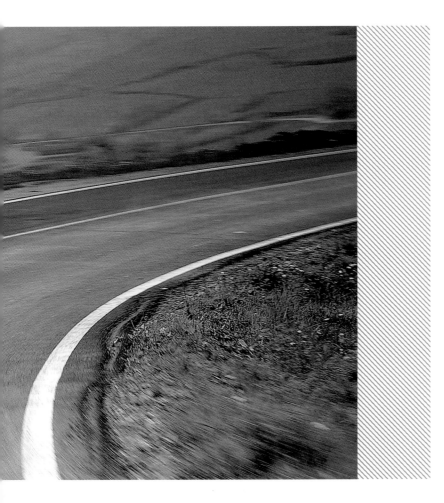

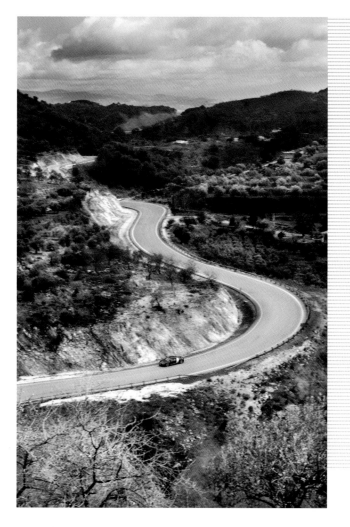

Audi R8 V10

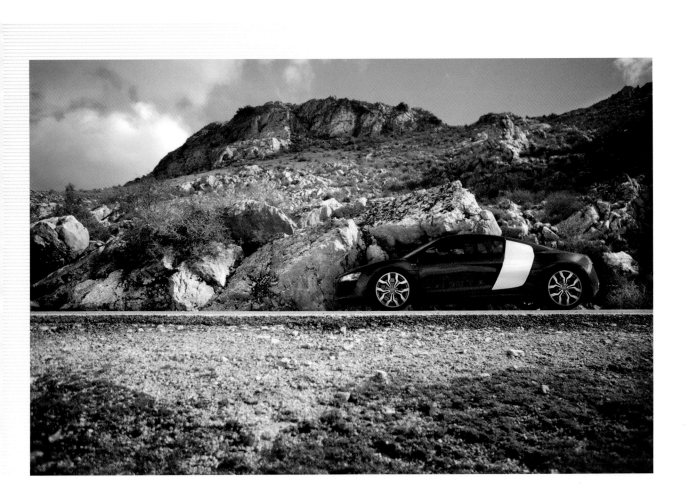

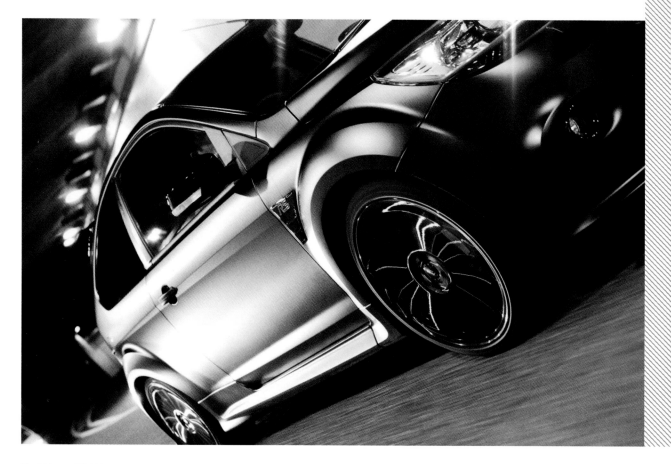

Ford Focus RS500

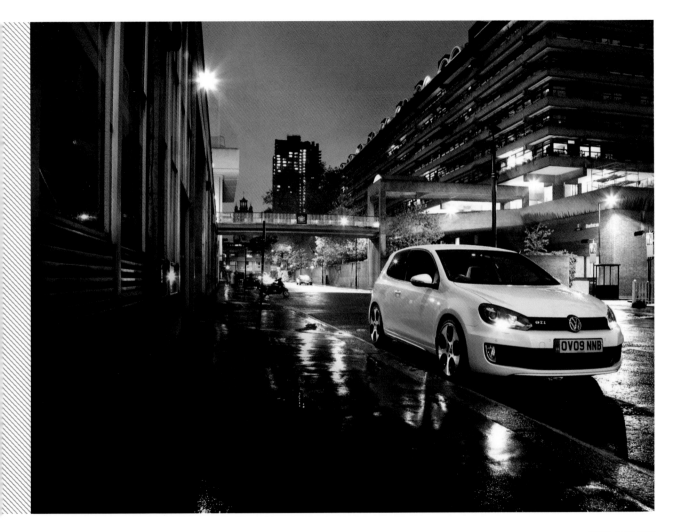

VW Golf GTi

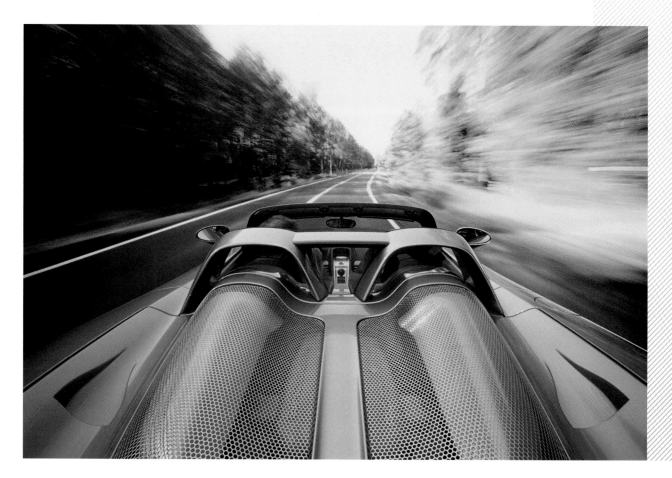

Porsche Carrera GT

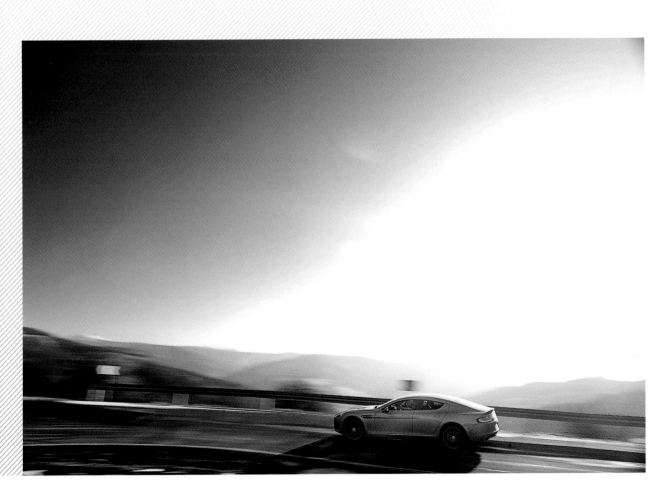

Aston Martin Rapide

Dodge Viper

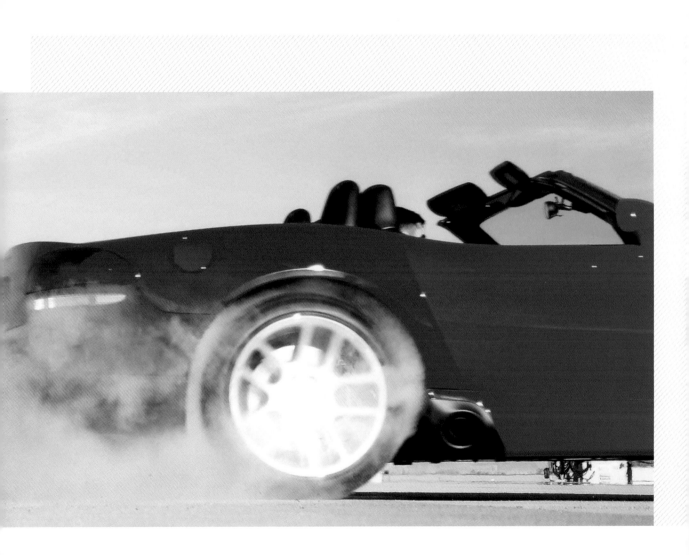

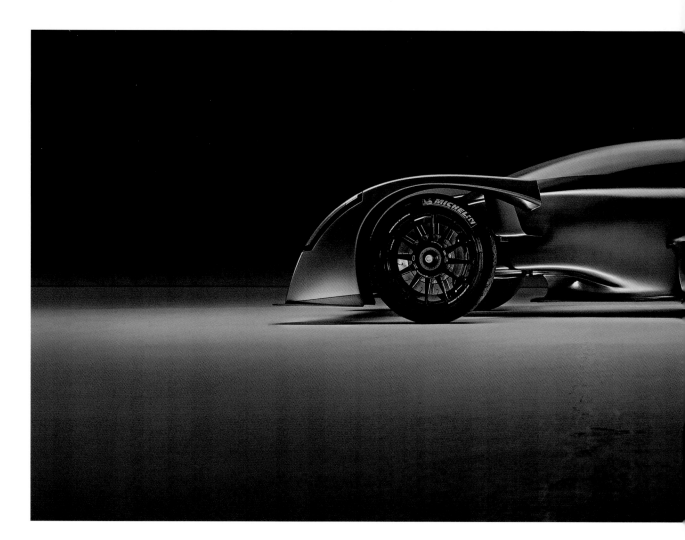

Caparo T1

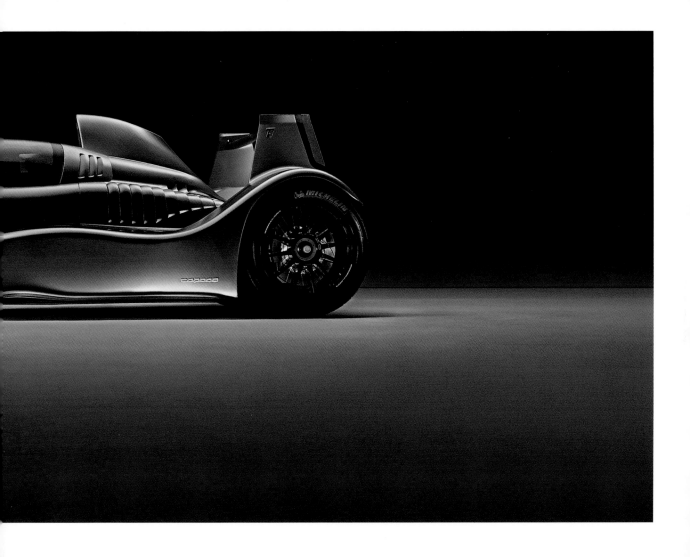

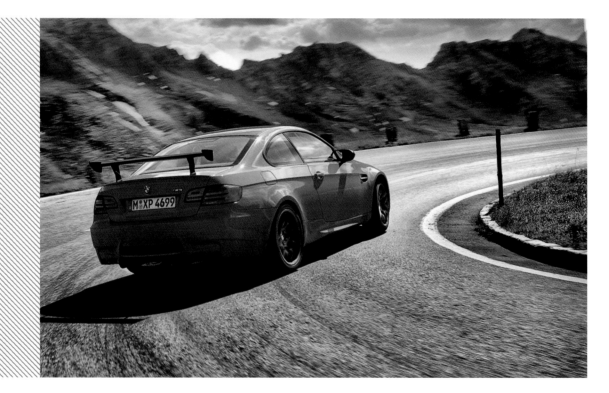

BMW M3 GTS

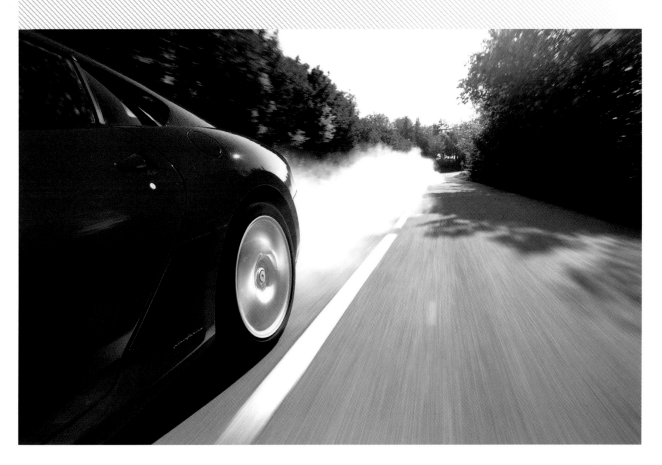

Ferrari 599

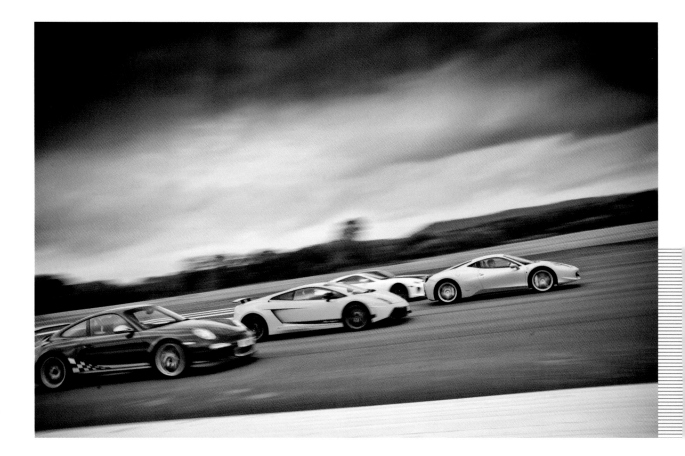

Porsche 911 GT3 RS; Lamborghini Gallardo Superleggera; Ferrari 458 Italia

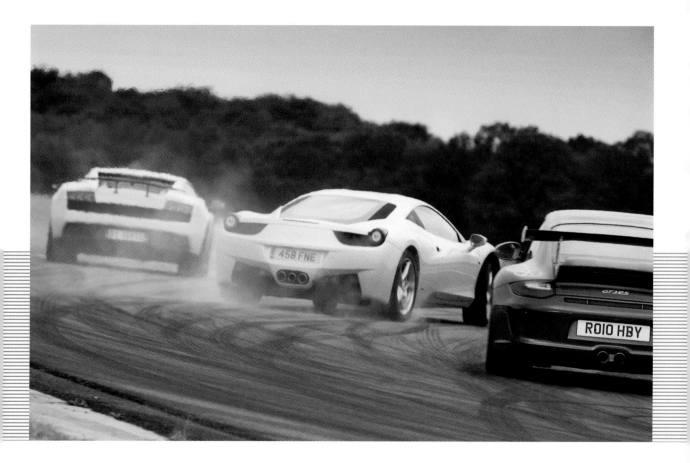

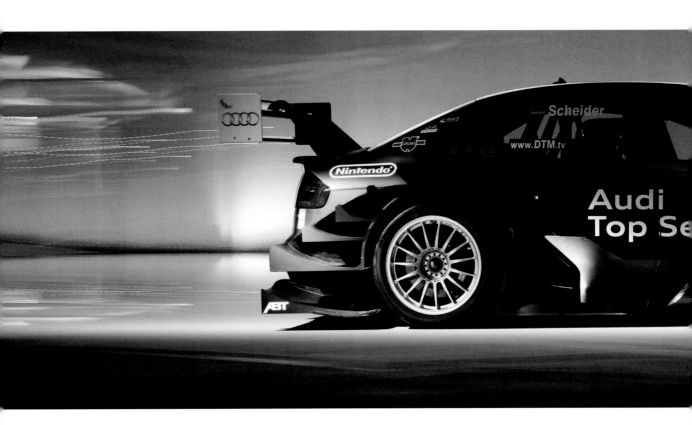

Audi A4 DTM

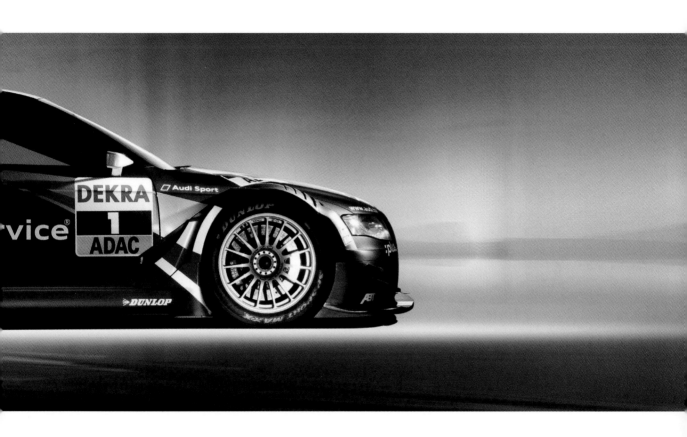

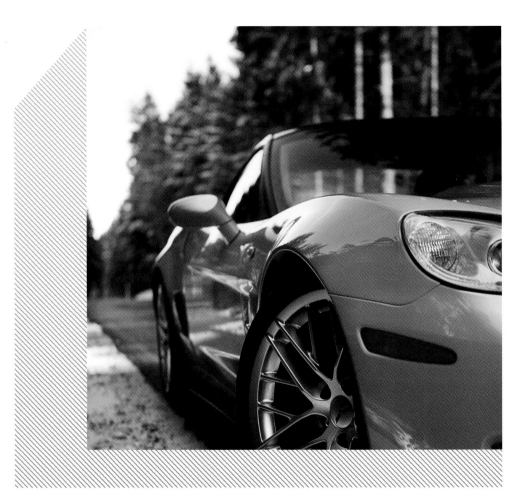

Chevrolet Corvette ZR1

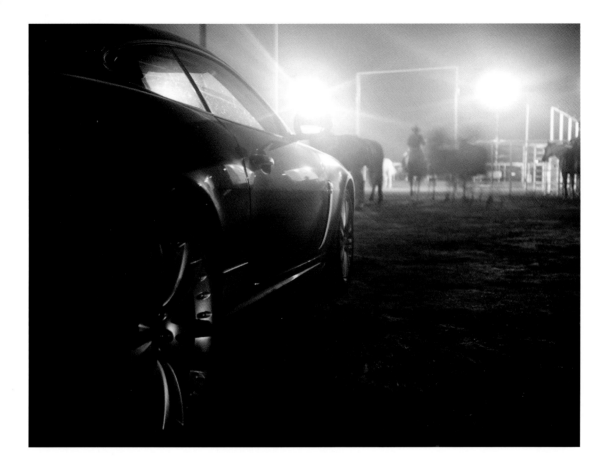

Jaguar XKR

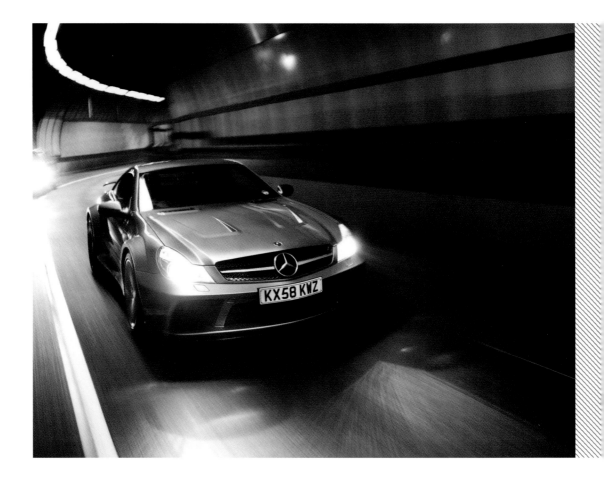

Mercedes-Benz SL 65 AMG Black

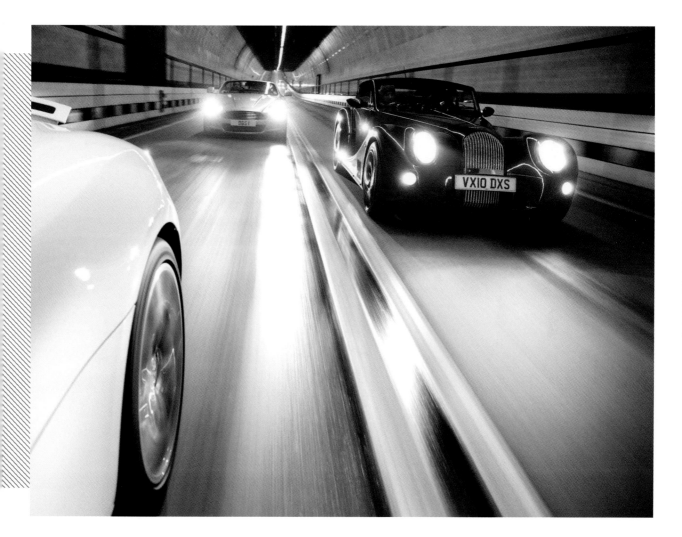

Aston Martin DBS Volante; Morgan Aero Supersports

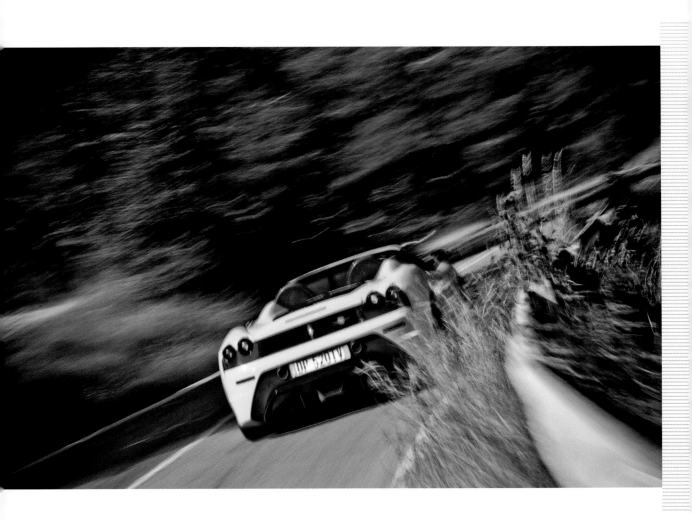

Ferrari Scuderia Spider 16M

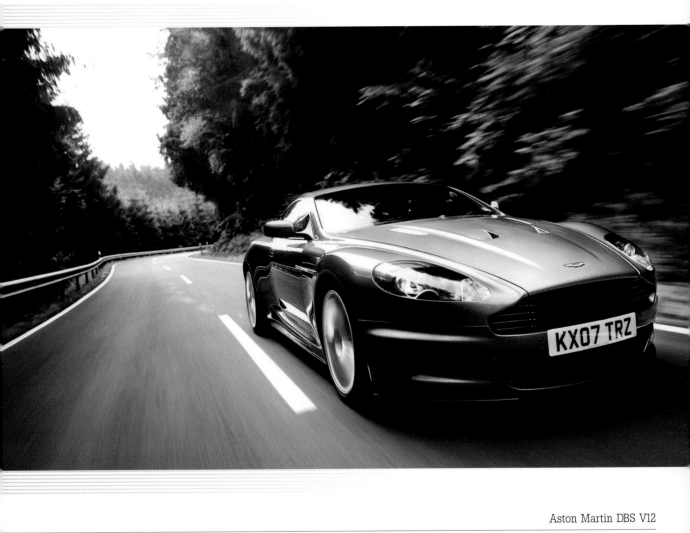

Aston Martin DBS V12

Lamborghini Gallardo LP560-4

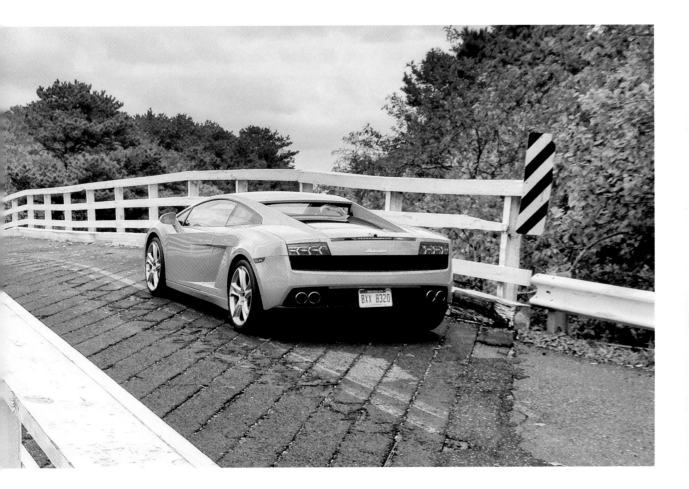

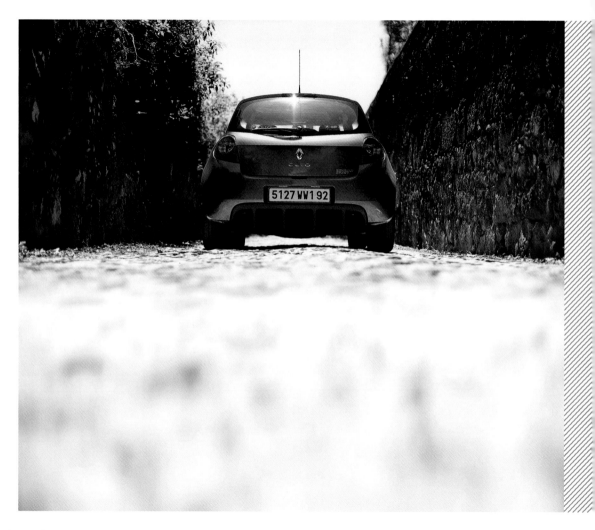

Renaultsport Clio 200

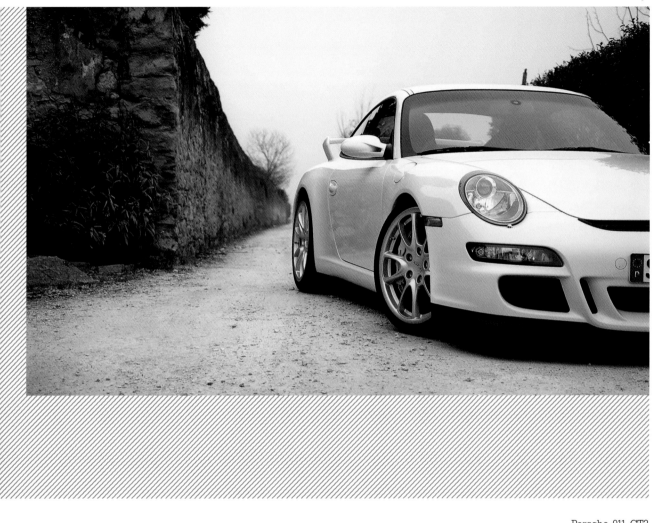

Porsche 911 GT3

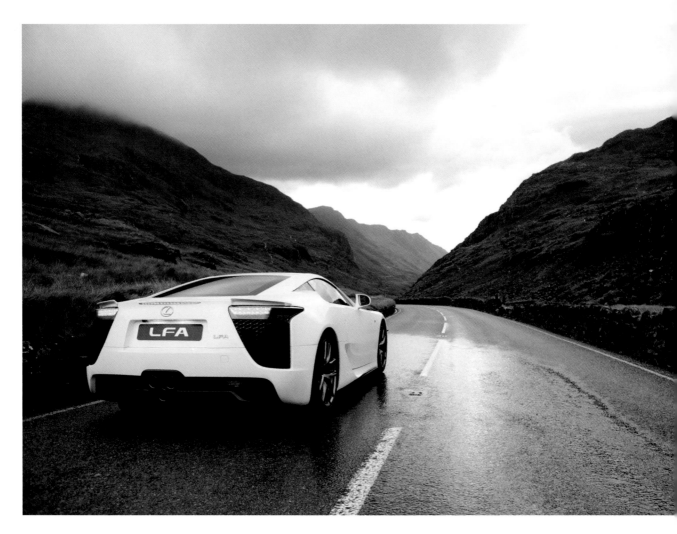

Lexus LFA

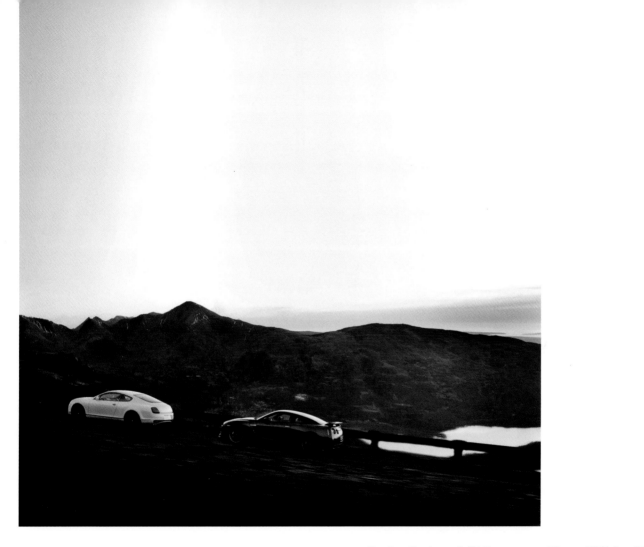

Bentley Continental GT Supersports; Nissan GT-R SpecV

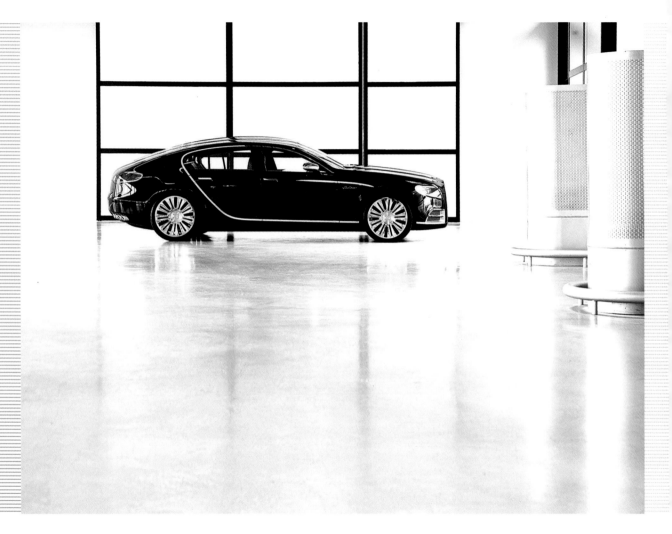

Bugatti 16C Galibier

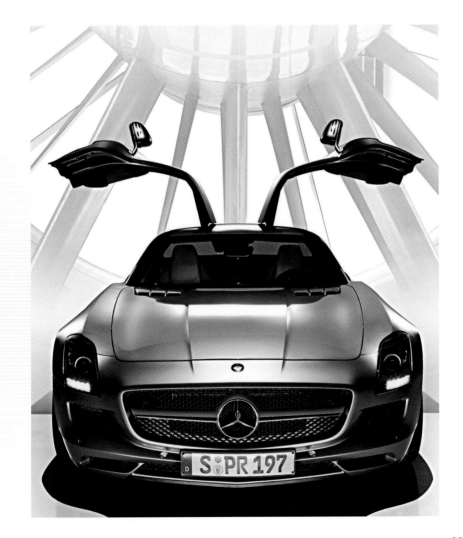

Mercedes-Benz SLS

Aston Martin V8 Vantage Roadster

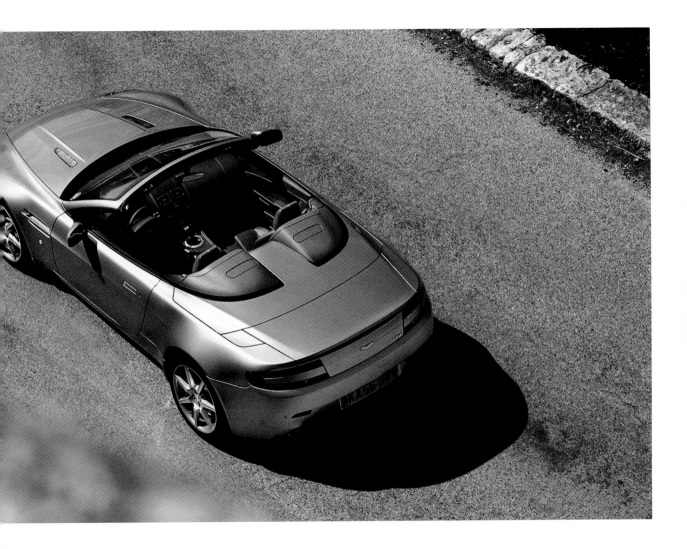

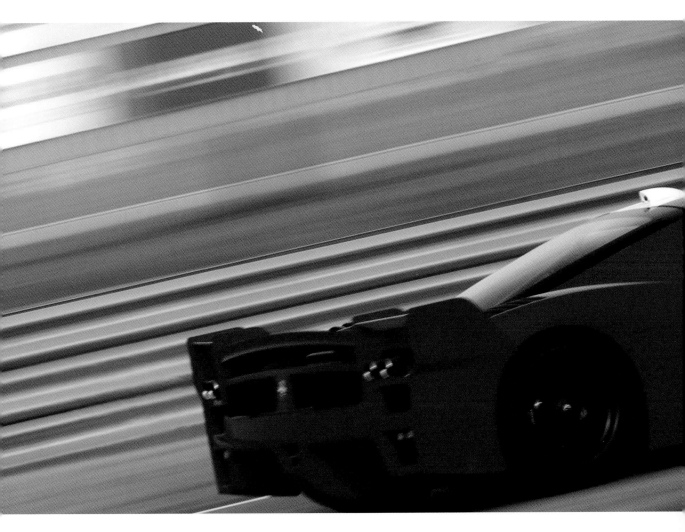

Ferrari FXX

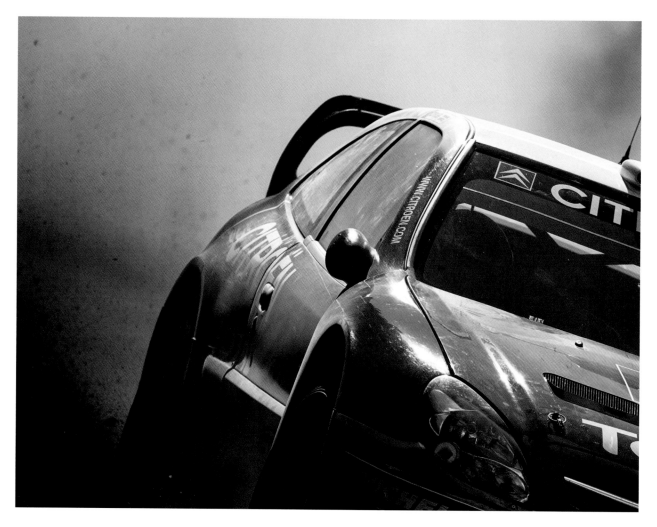

Citroën Xsara WRC

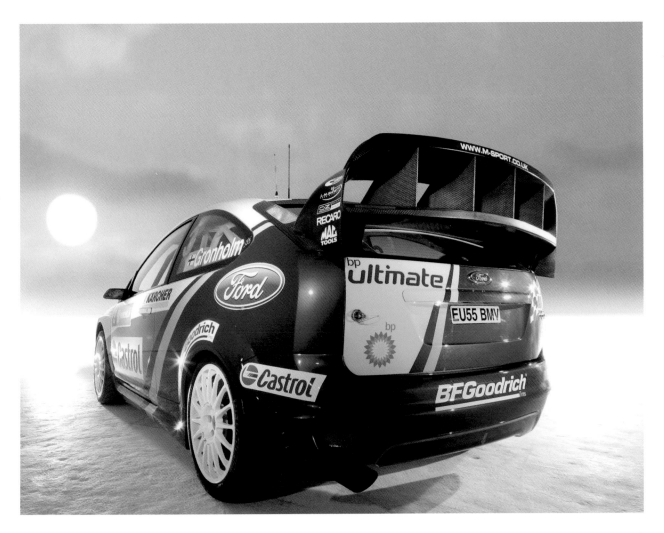

Ford Focus RS WRC

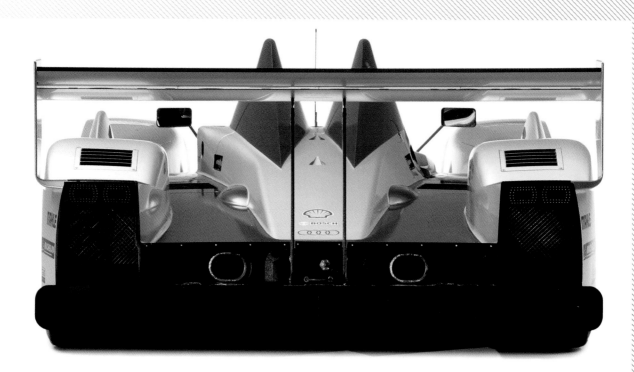

Audi R8 Le Mans

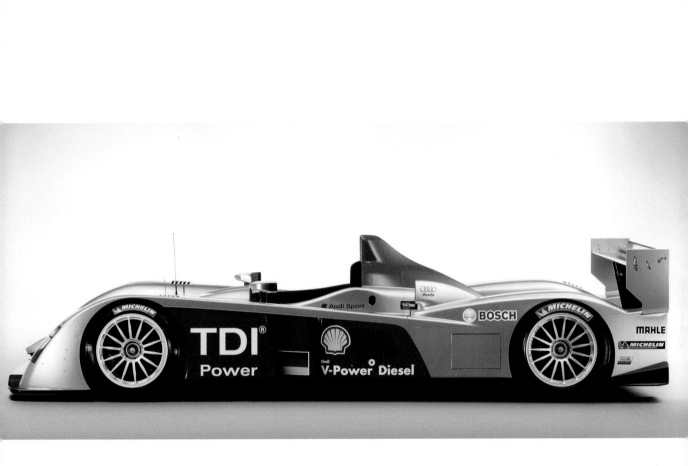

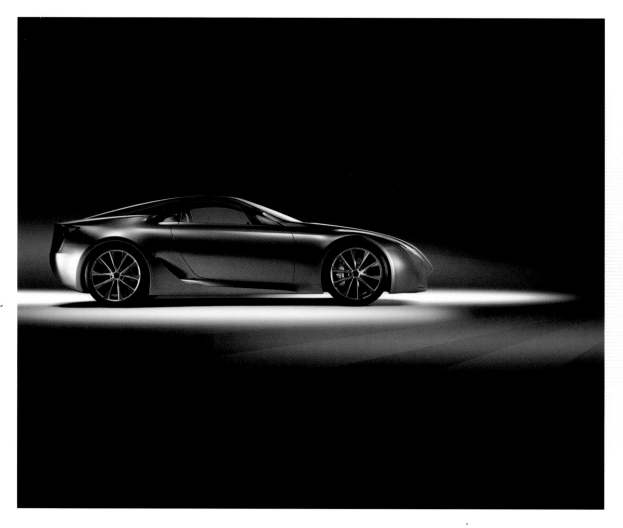

Lexus LF-A Concept

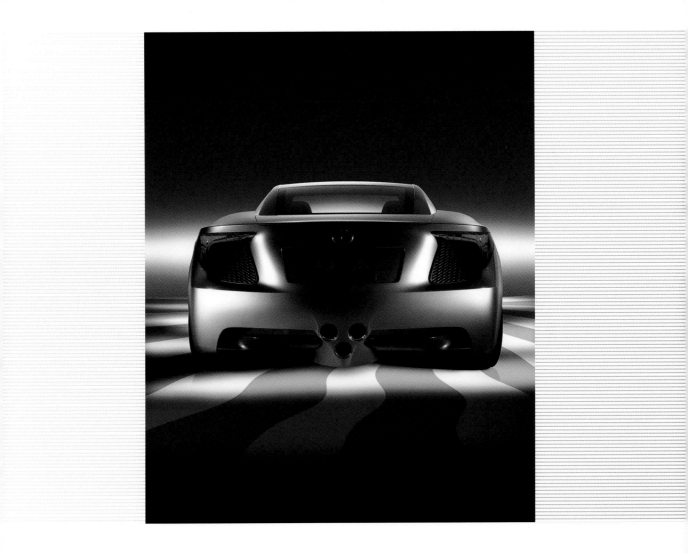

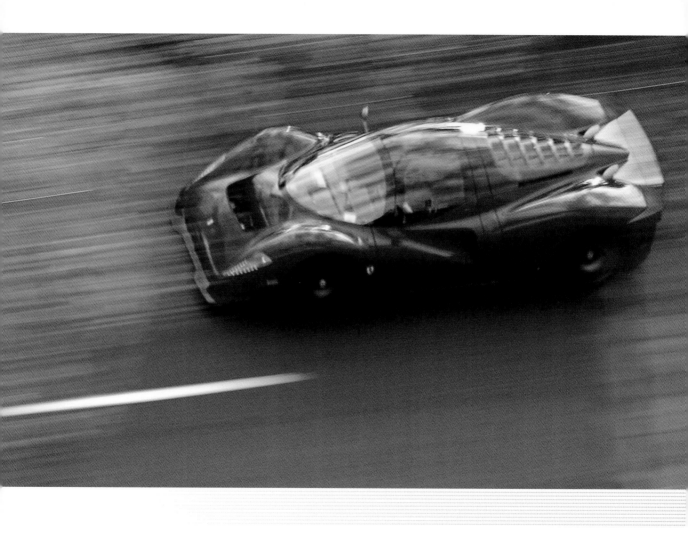

Ferrari P4 Concept

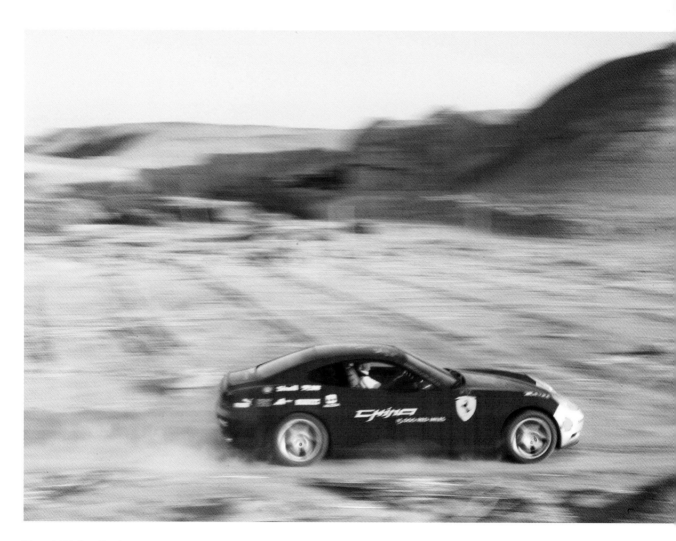

Ferrari 612 Scaglietti

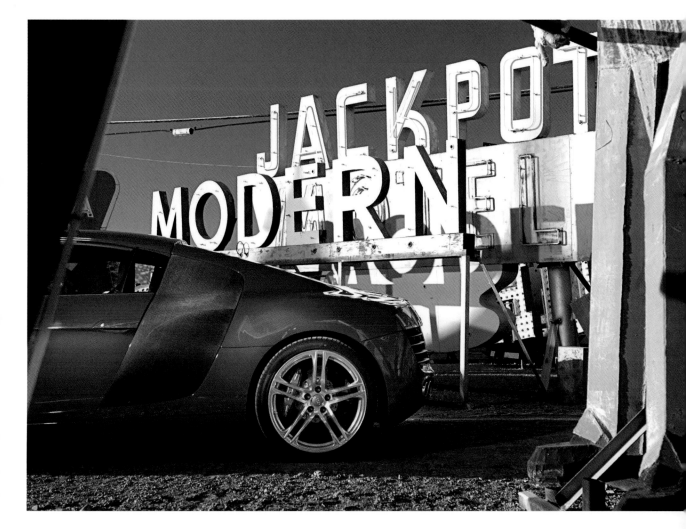

Audi R8

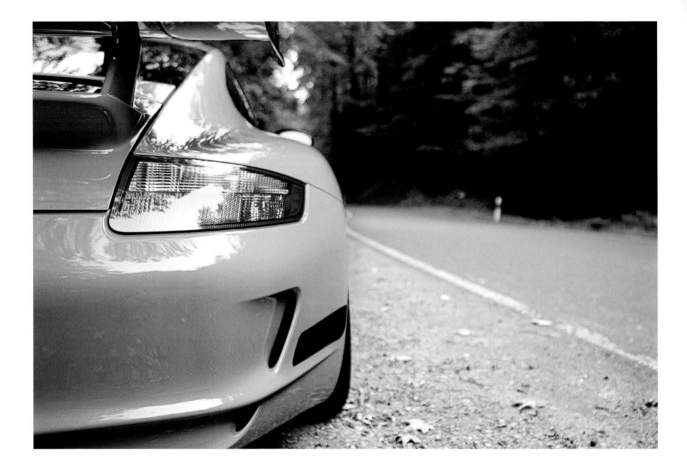

Porsche 911 GT3 RS

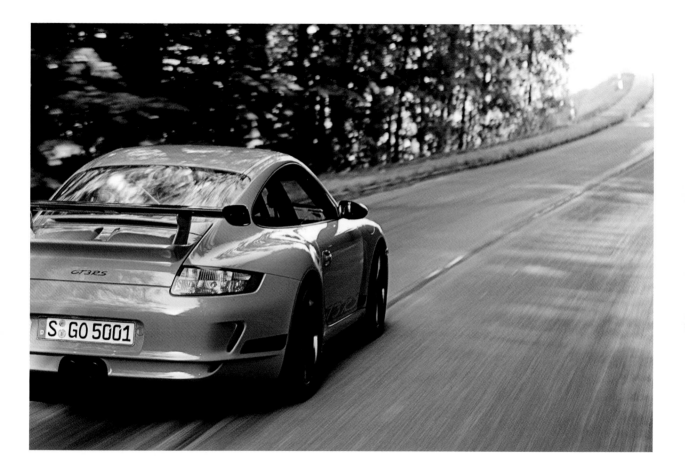

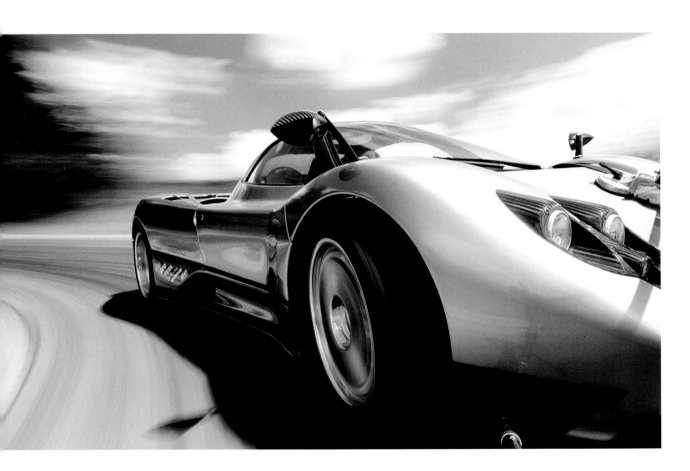

Pagani Zonda C12

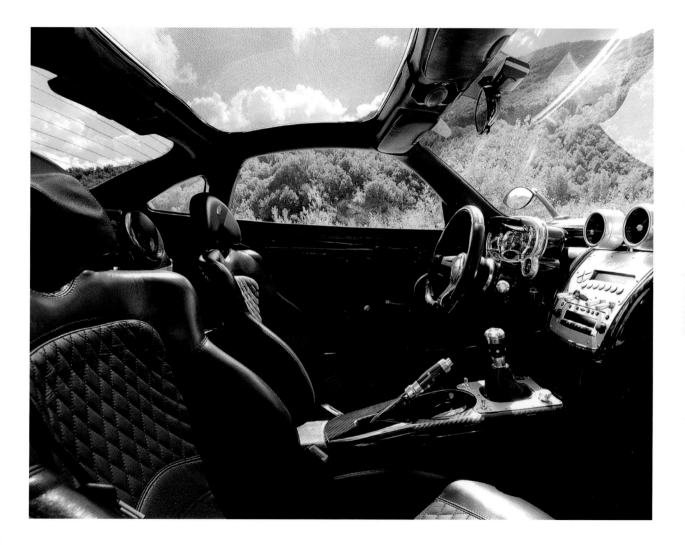

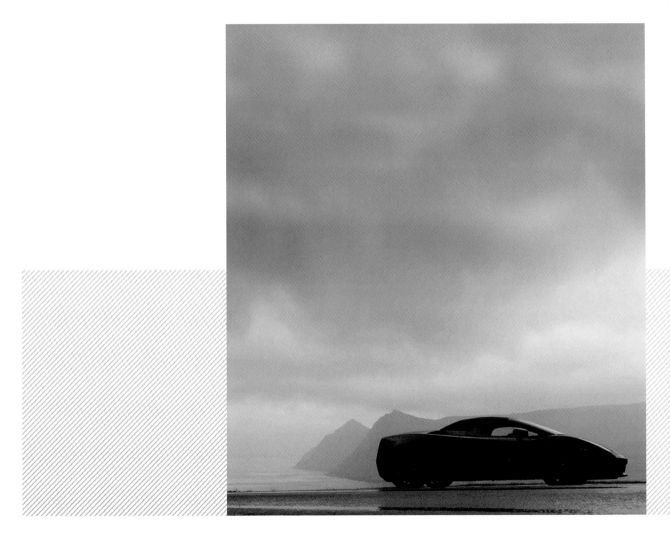

Lamborghini Gallardo Spyder

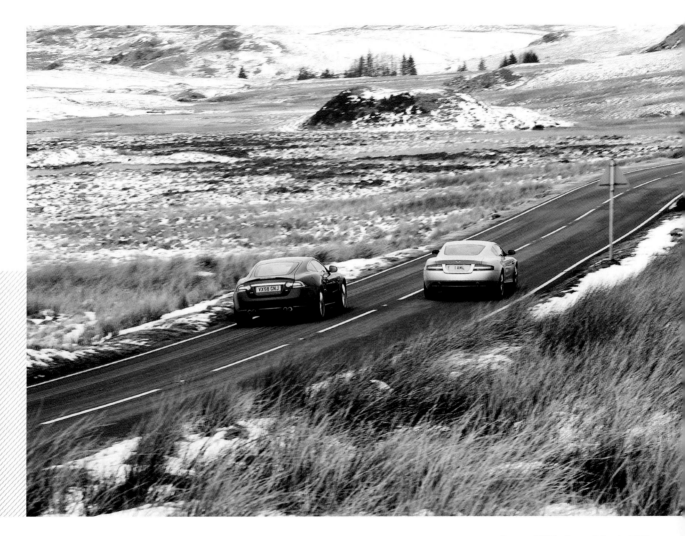

Jaguar XKR; Aston Martin DB9

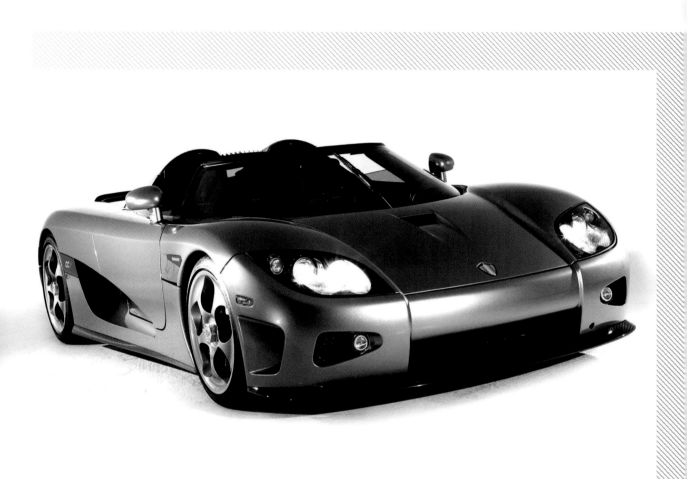

Koenigsegg CCXR

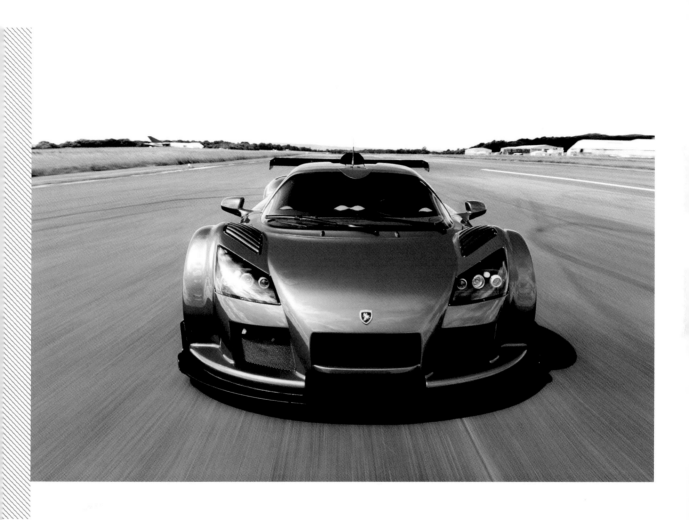

Gumpert Apollo

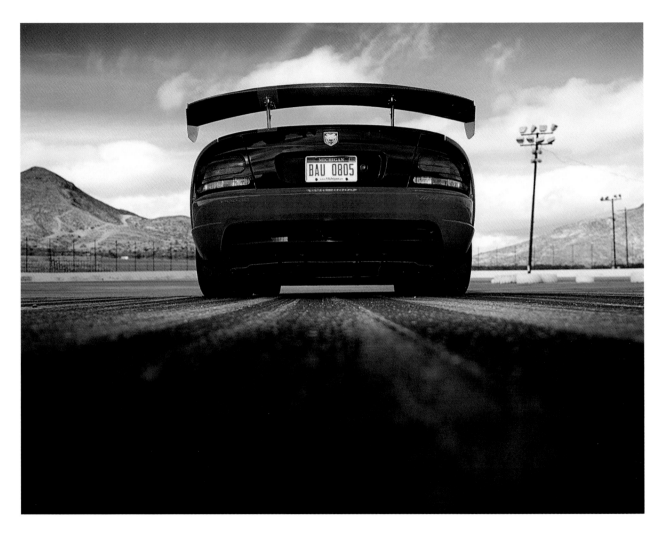

Dodge Viper ACR

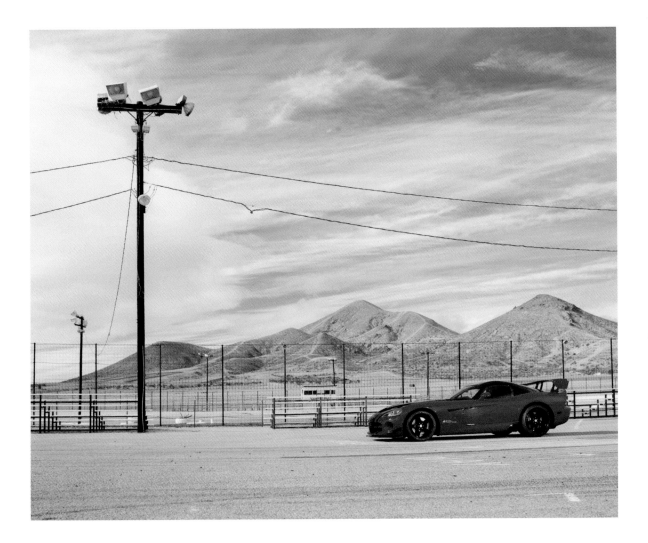

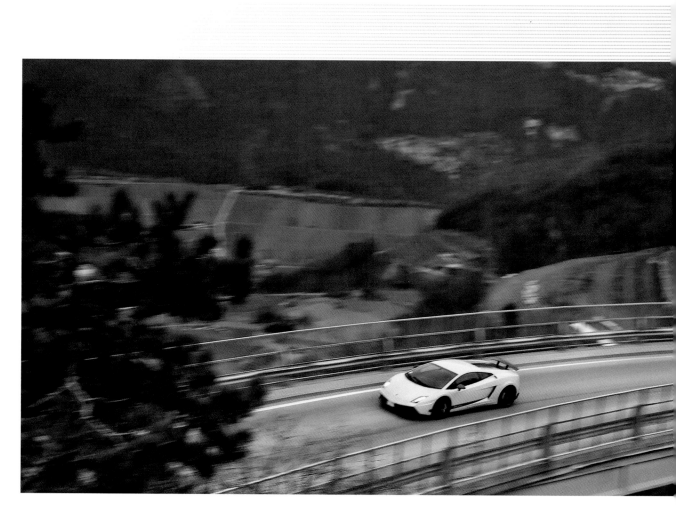

Lamborghini Gallardo Superleggera

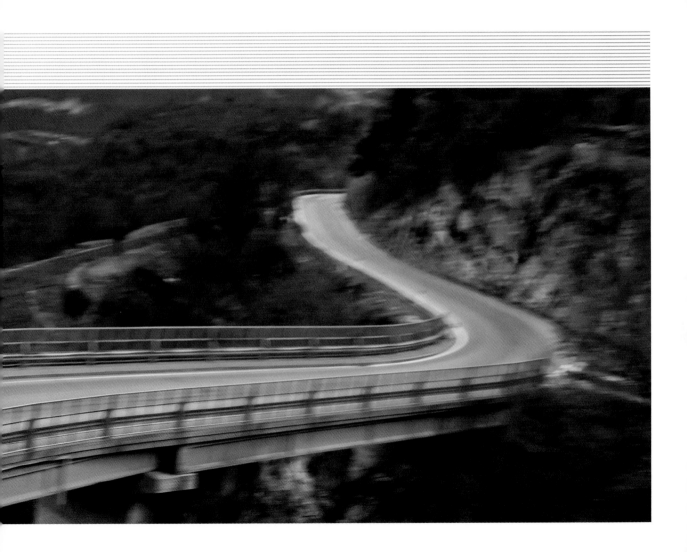

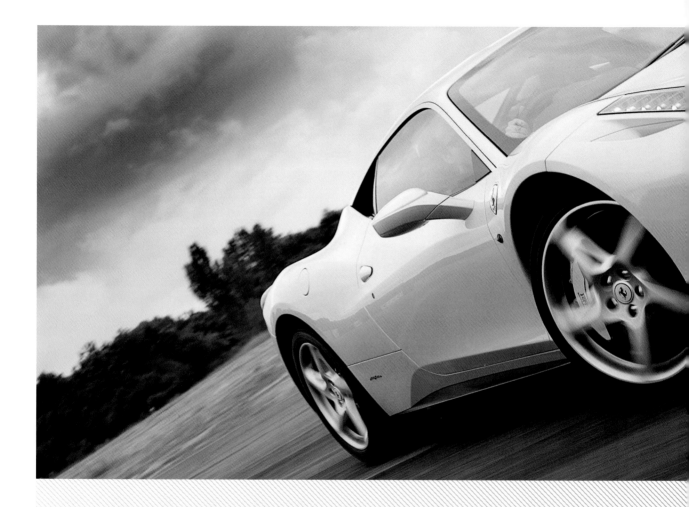

Ferrari 458 Italia

Lamborghini Reventón

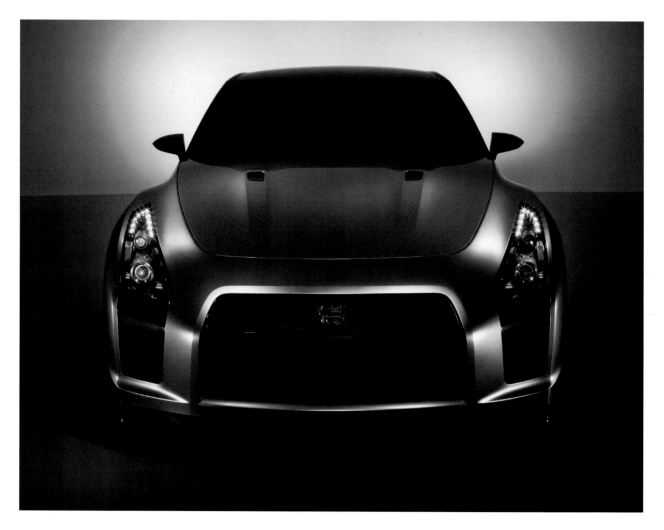

Nissan GT-R Concept

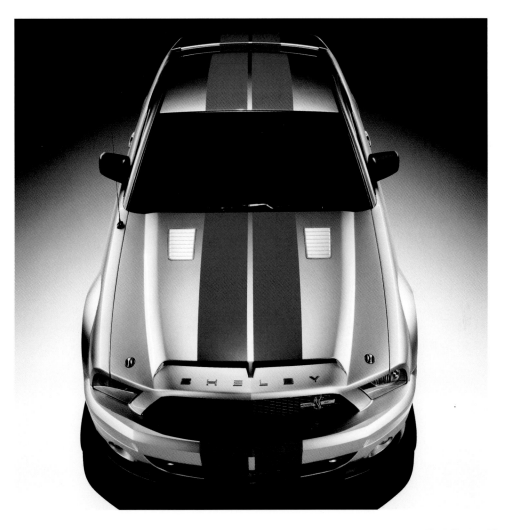

Ford Shelby Mustang GT500

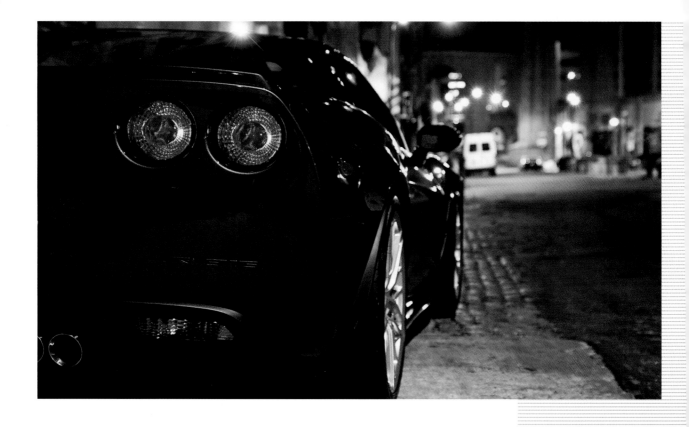

Chevrolet Corvette ZR1

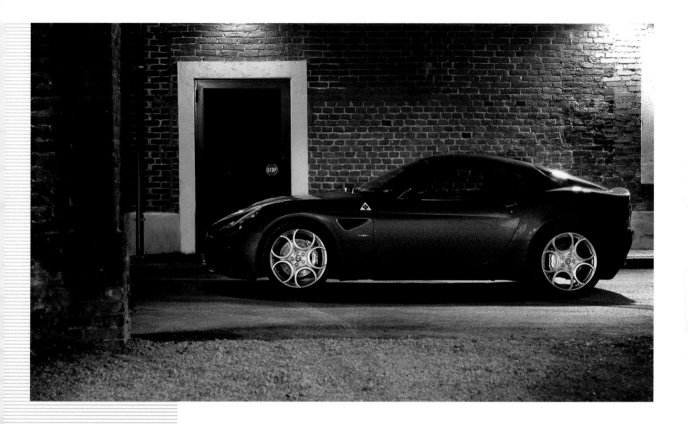

Alfa Romeo 8C

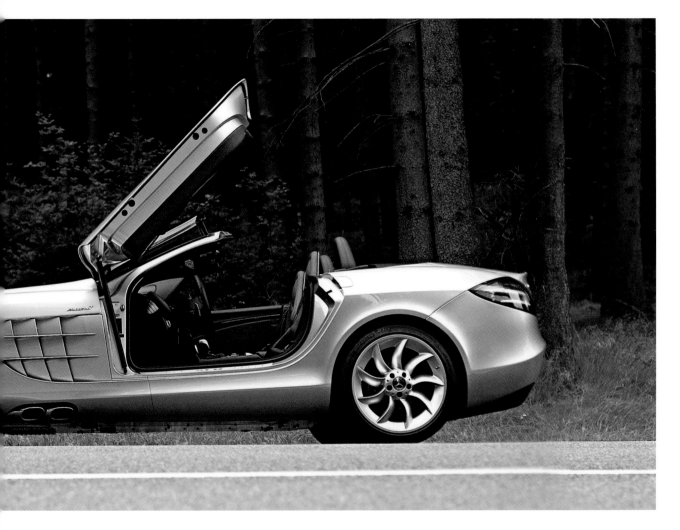

Mercedes-Benz SLR McLaren Roadster

McLaren MP4-12C

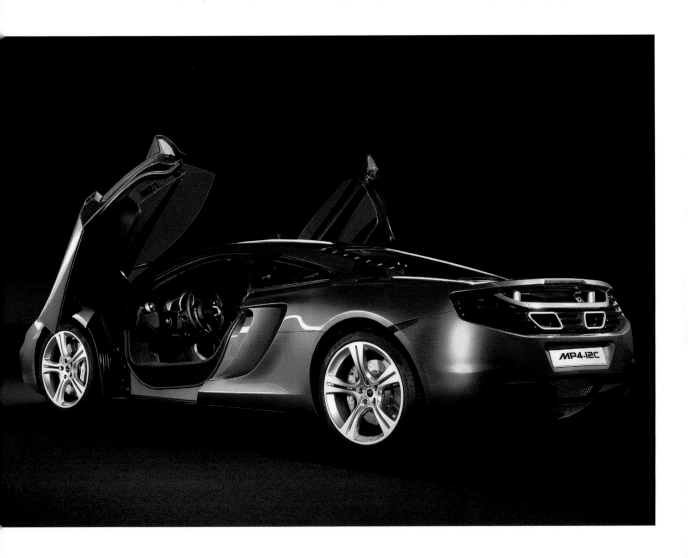

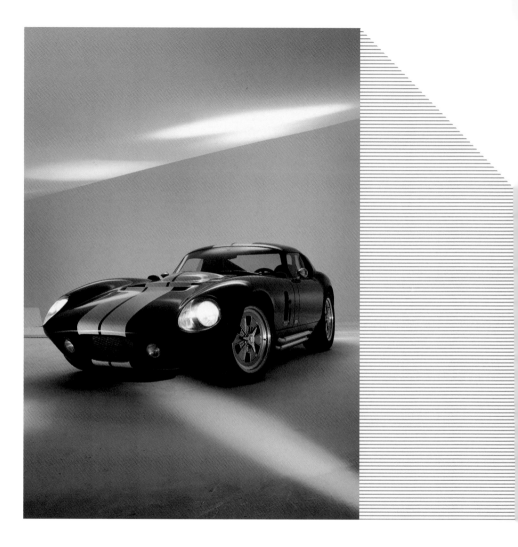

Shelby Cobra Retro

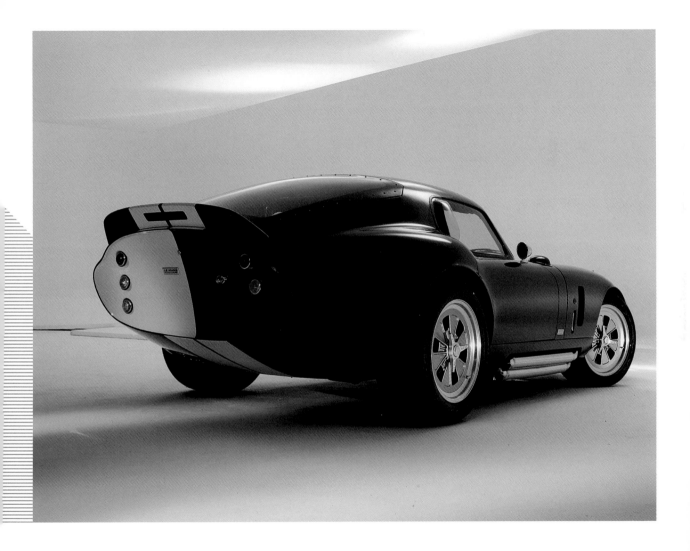

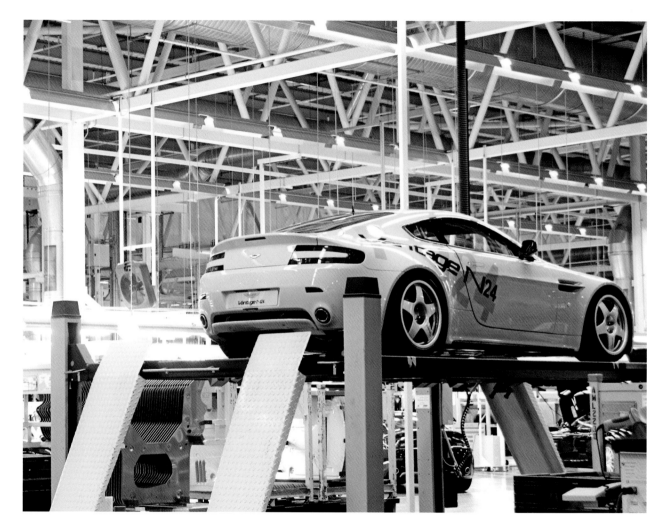

Aston Martin Vantage N24

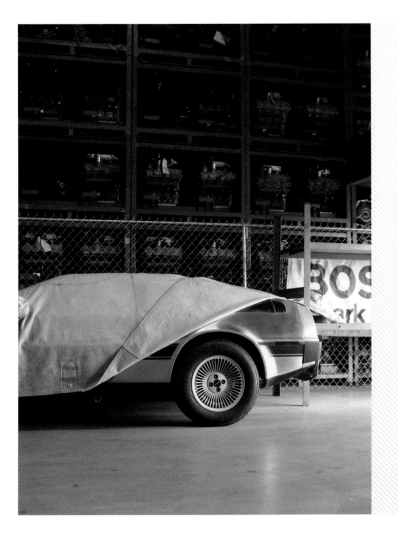

DeLorean

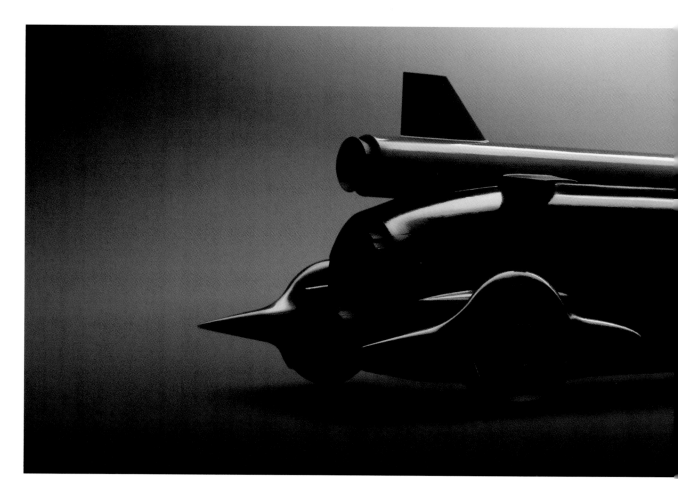

Bloodhound SSC

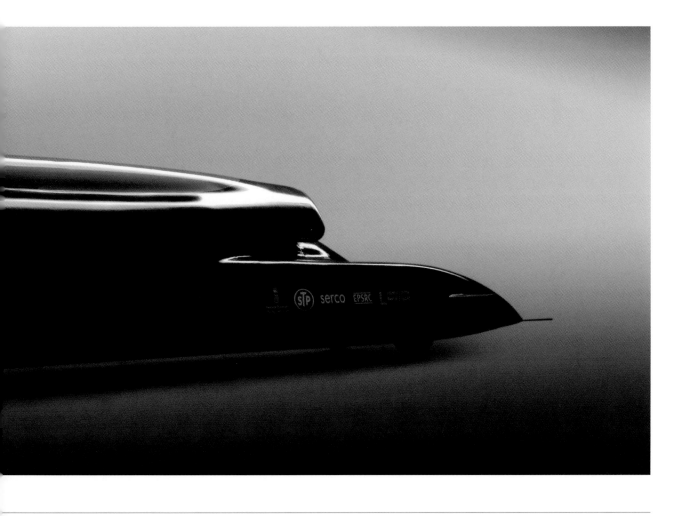

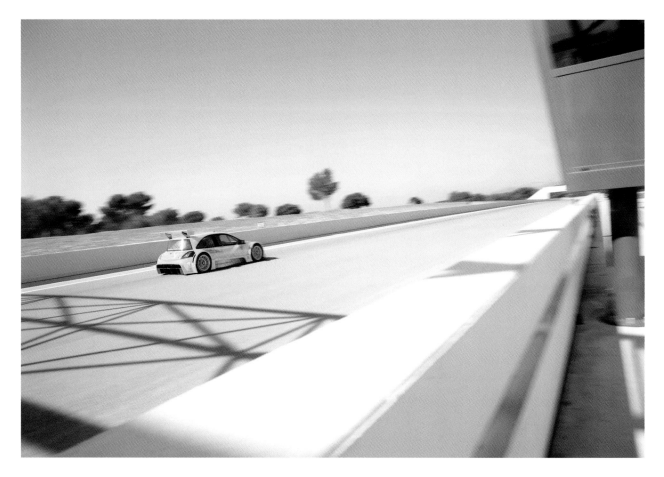

Renault Sport Megane Trophy

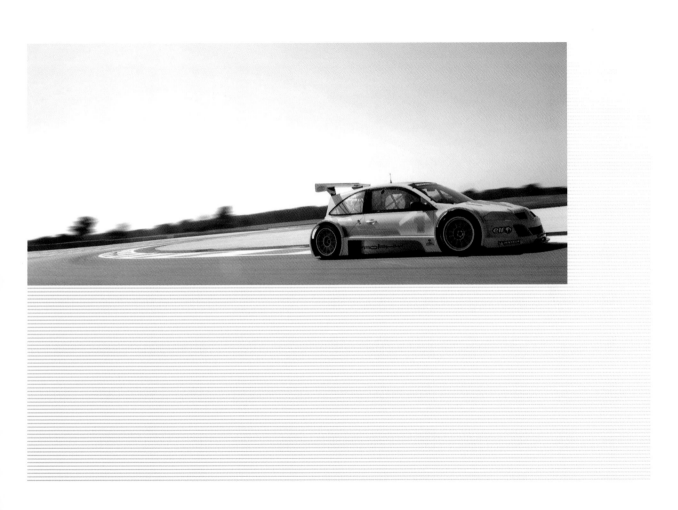

Porsche 911 GT3 RS

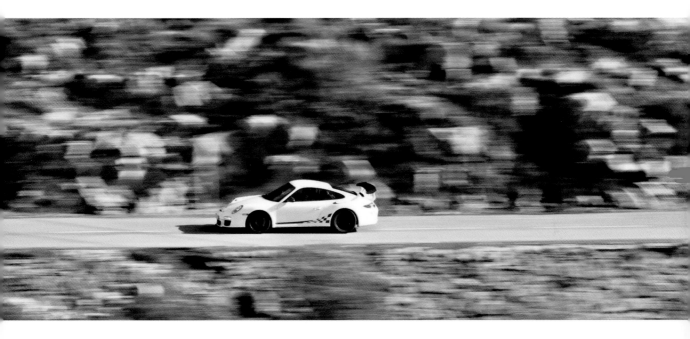

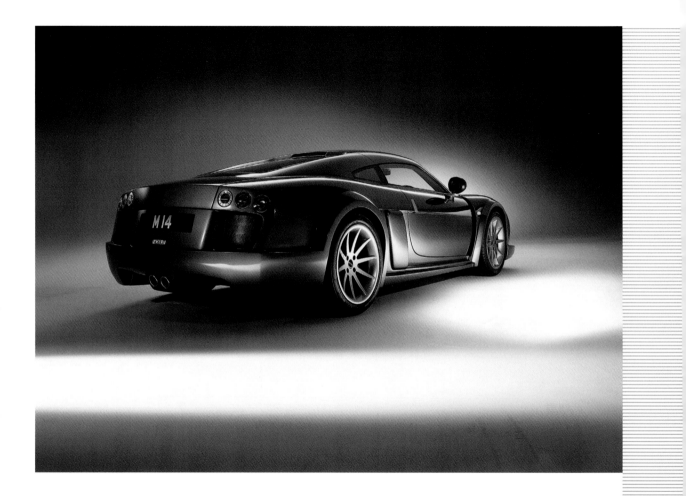

Noble M14

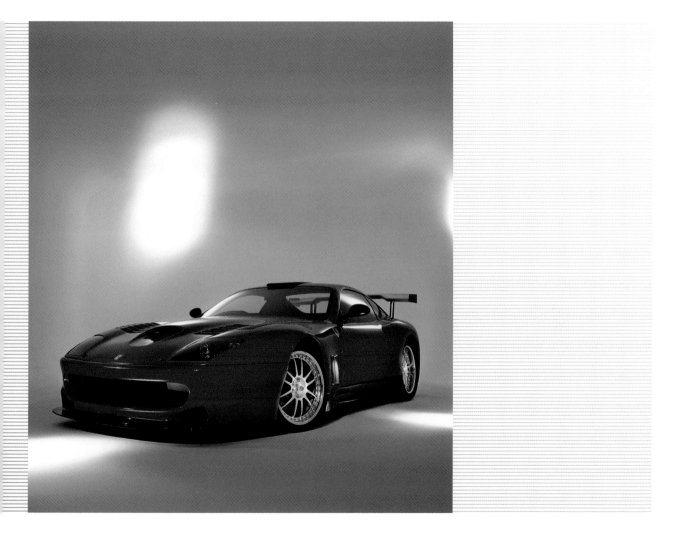

Ferrari 550 LM

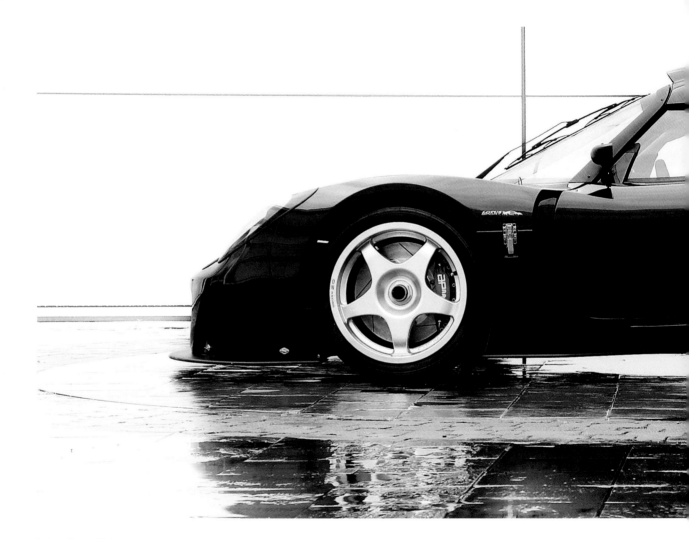

Lotus Sport Exige

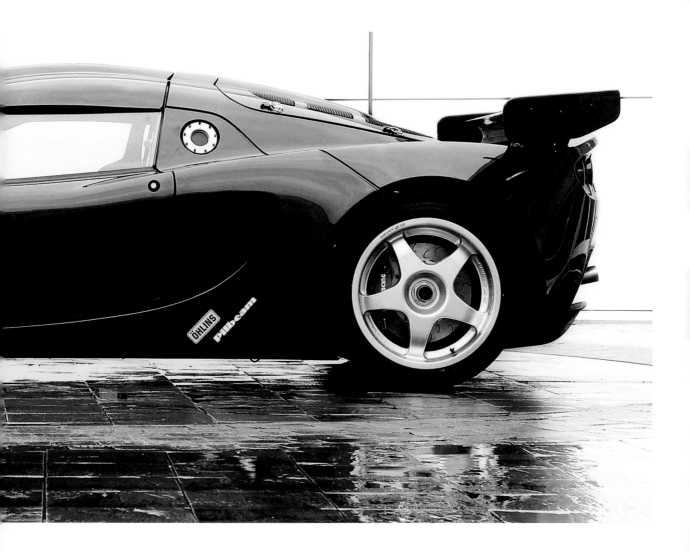

Mazda MX-5

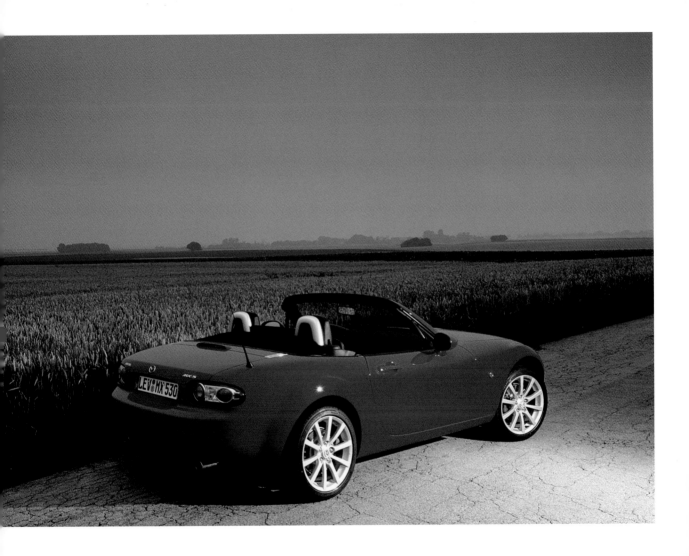

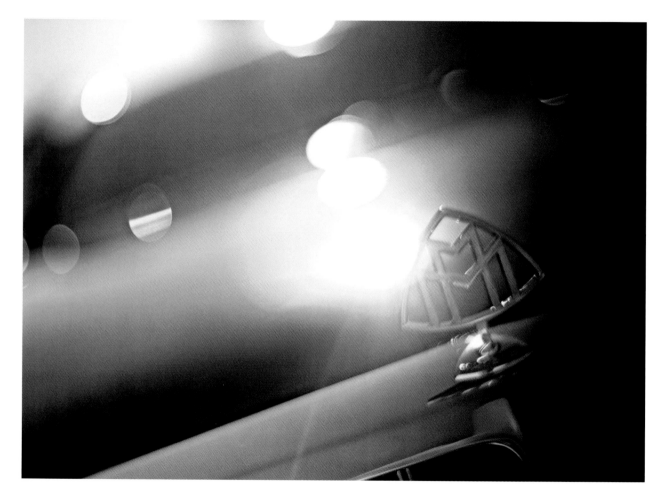

Maybach

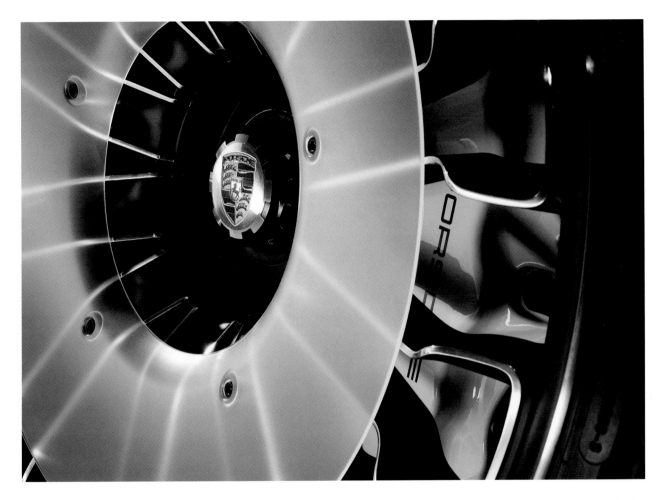

Porsche 918 Spyder

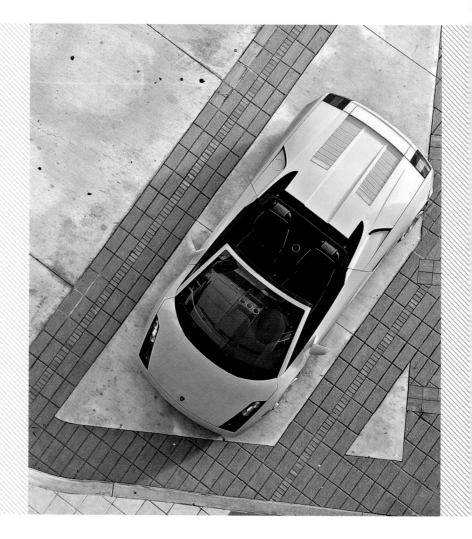

Lamborghini Gallardo Spyder

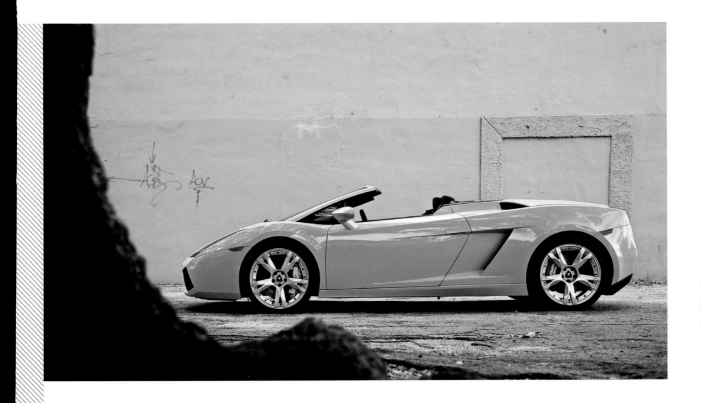

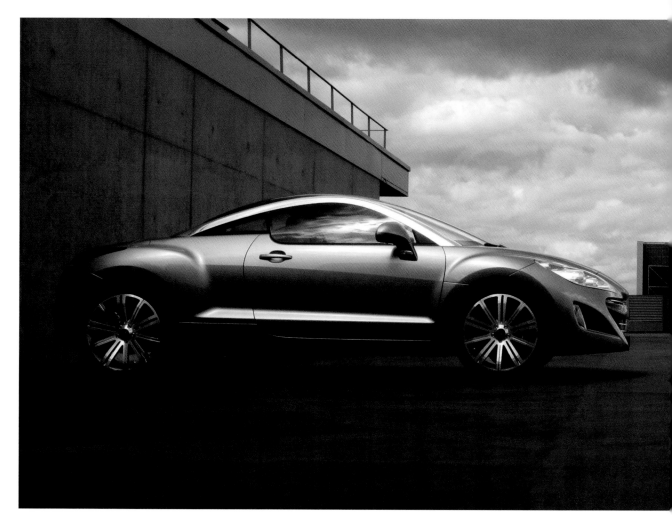

Peugeot 308 RCZ Concept

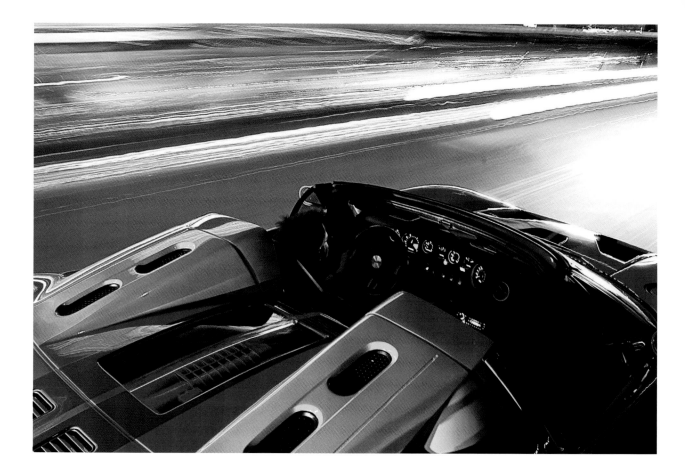

Ford GTX1

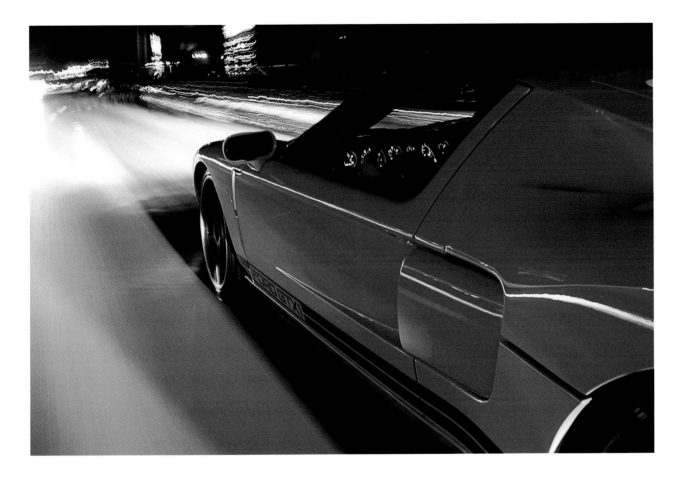

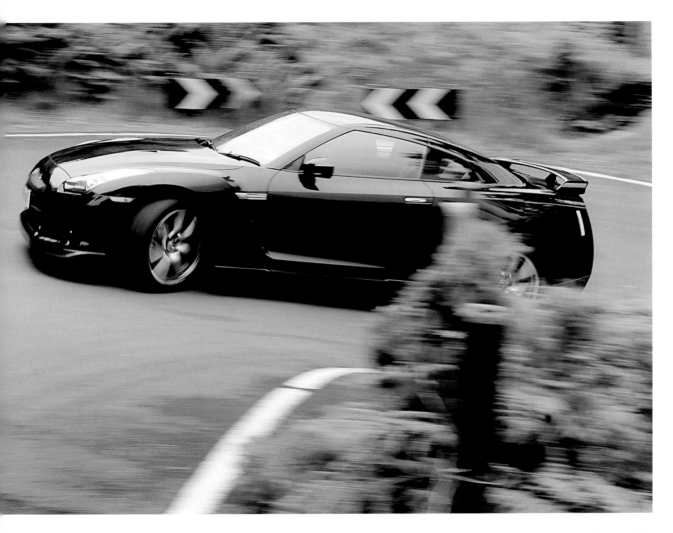

Nissan GT-R

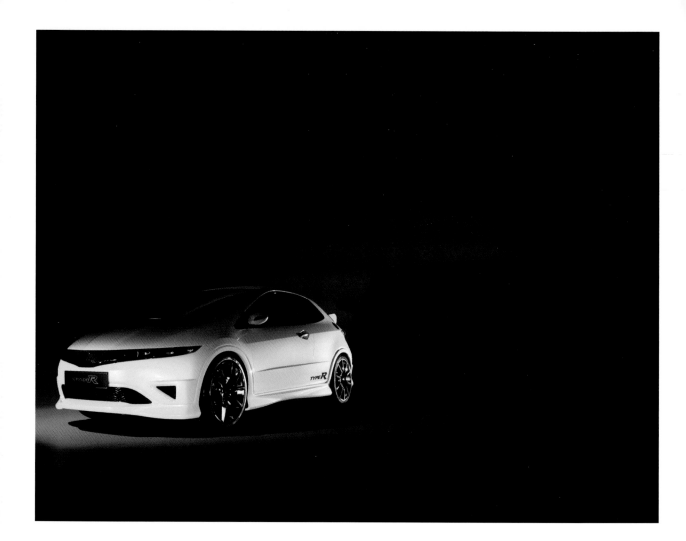

Honda Civic Type R

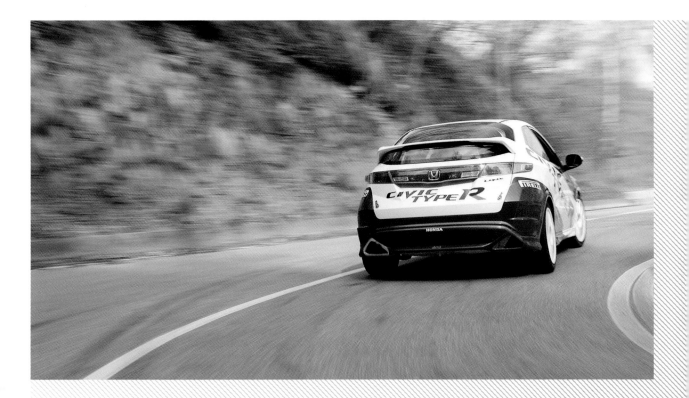

Honda Civic Type RR

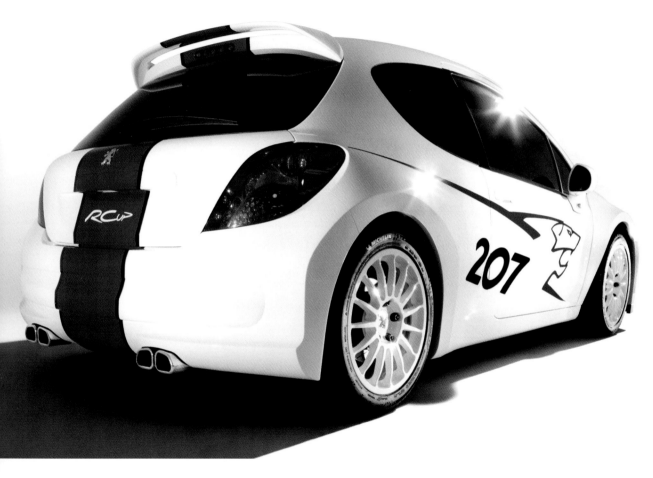

Peugeot 207 RCup

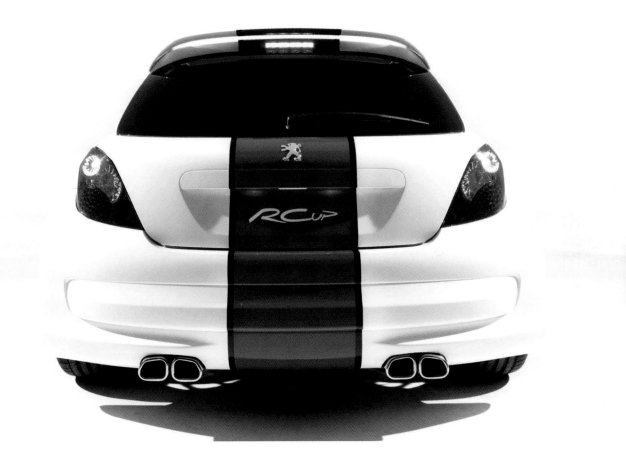

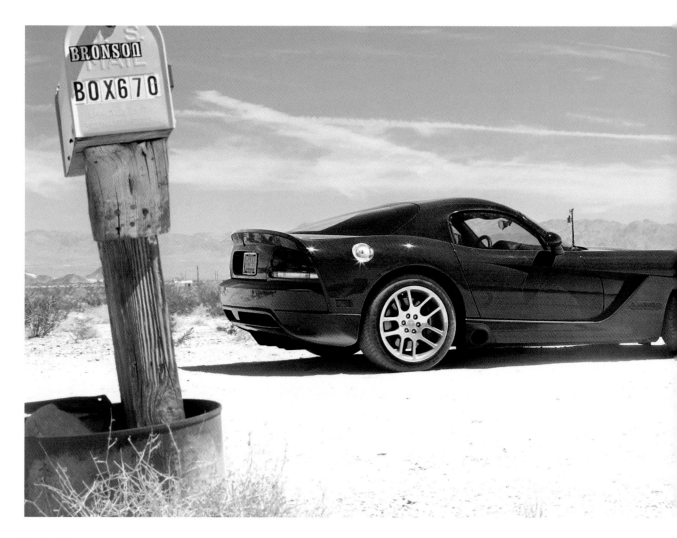

Dodge Viper

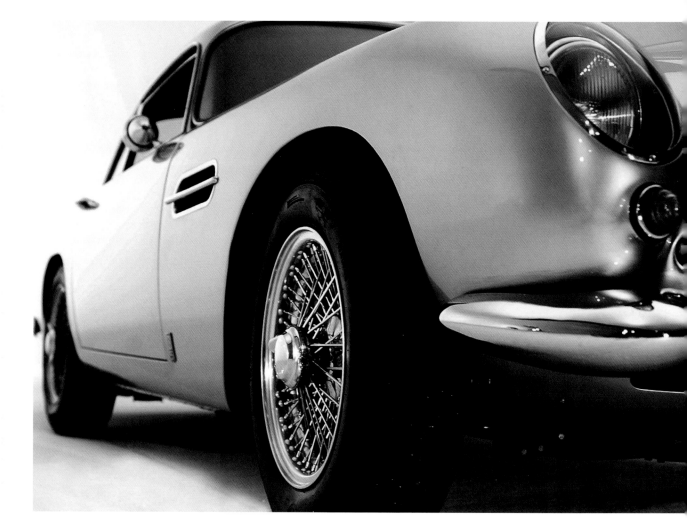

Aston Martin DB5

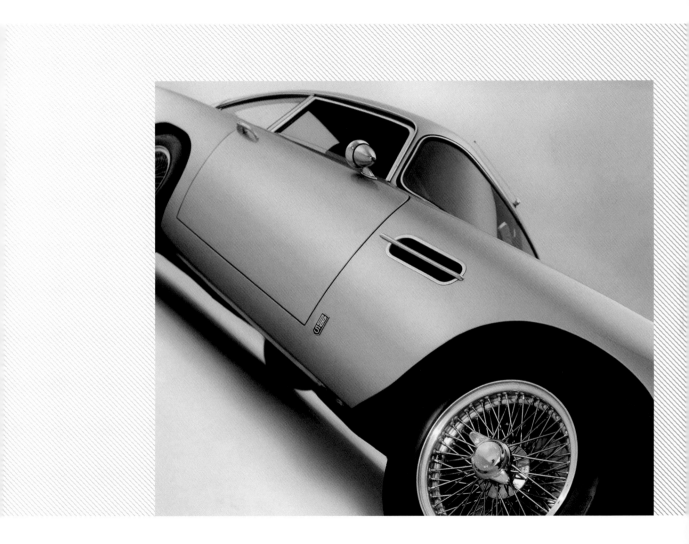

Peugeot 908 HDI

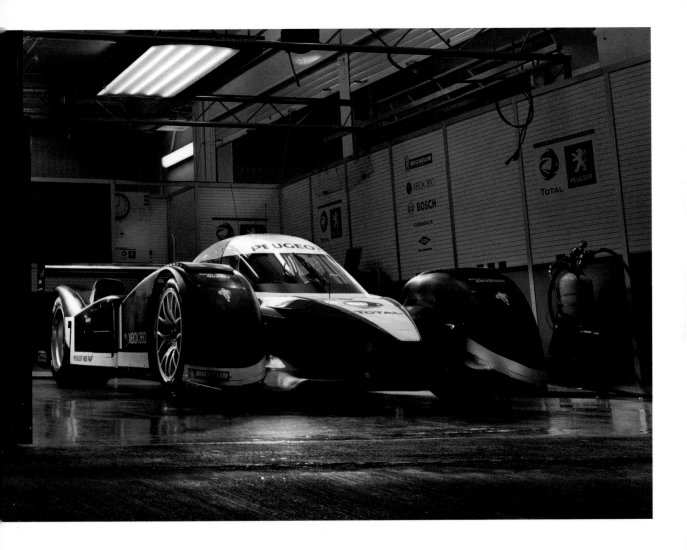

Hennessey Venom GT

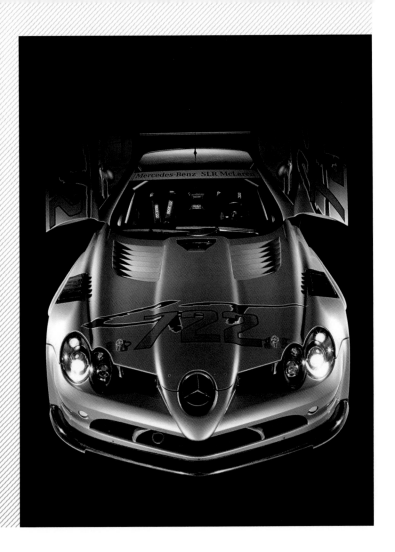

Mercedes-Benz SLR McLaren 722 GT

Bentley Azure

McLaren F1

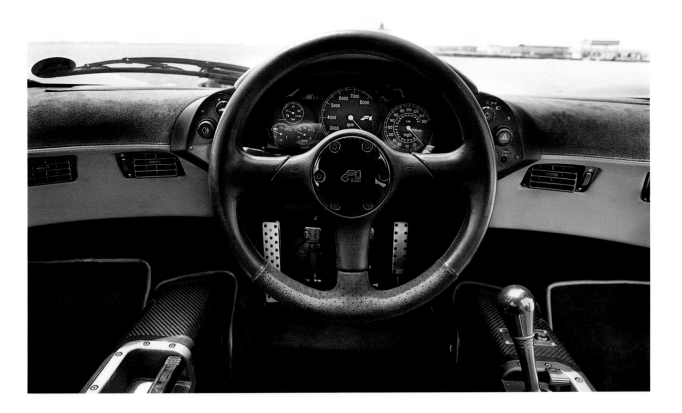

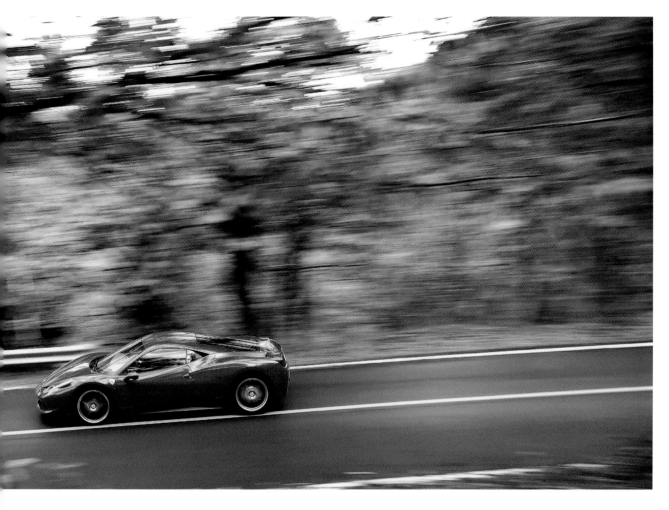

Ferrari 458 Italia

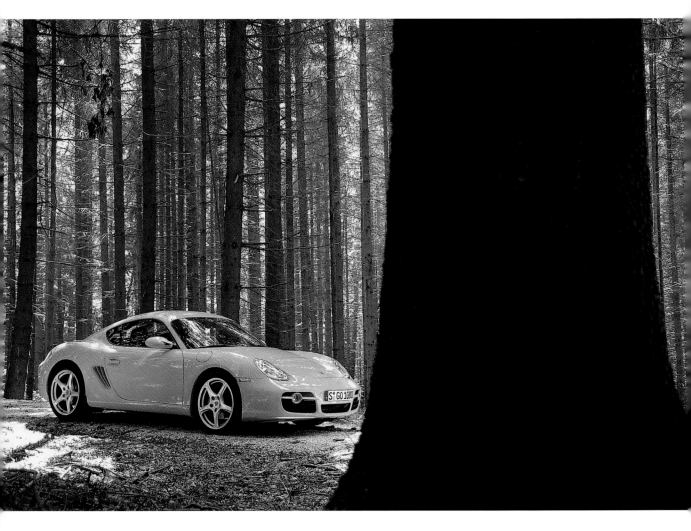

Porsche Cayman S

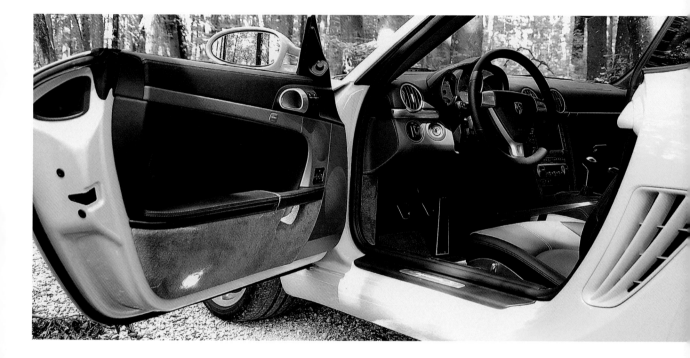

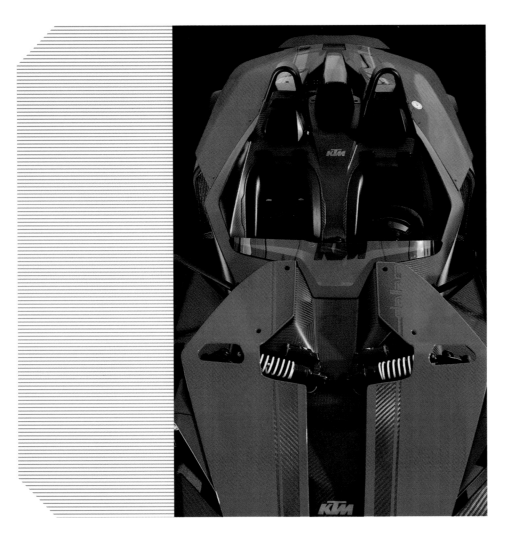

KTM X-Bow

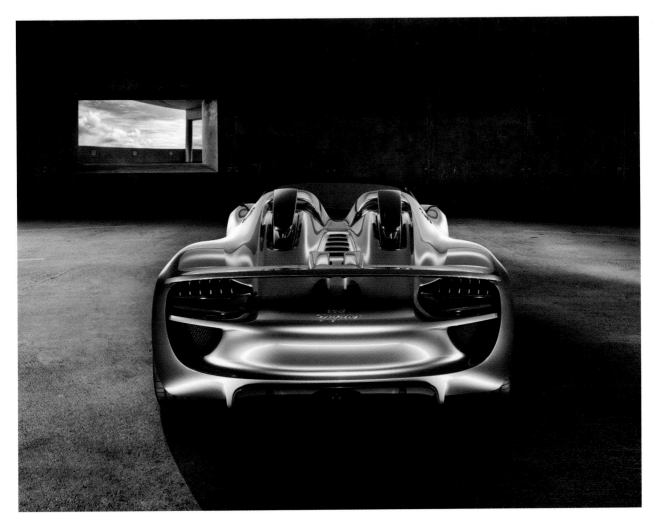

Porsche 918 Spyder

Ariel Atom V8

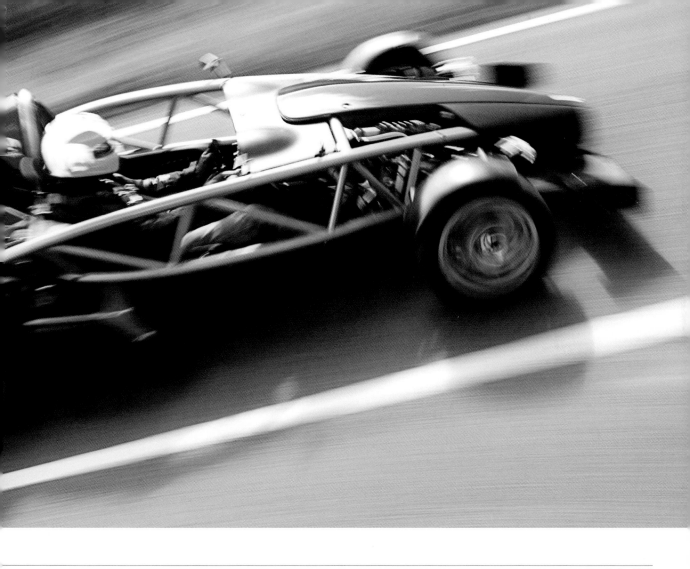

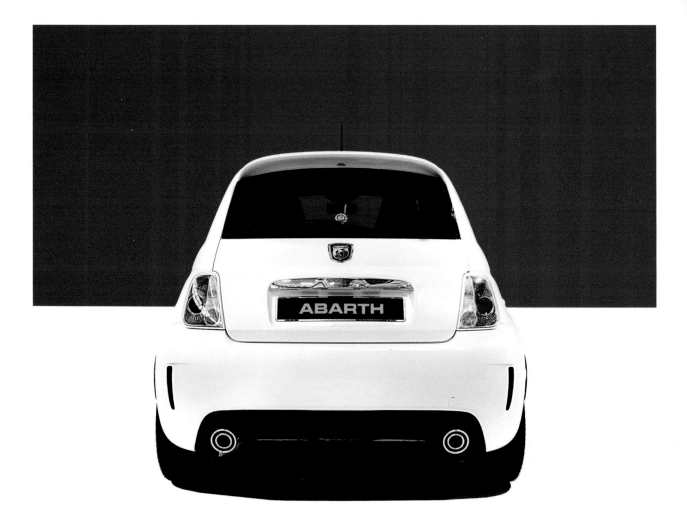

Fiat 500 Abarth

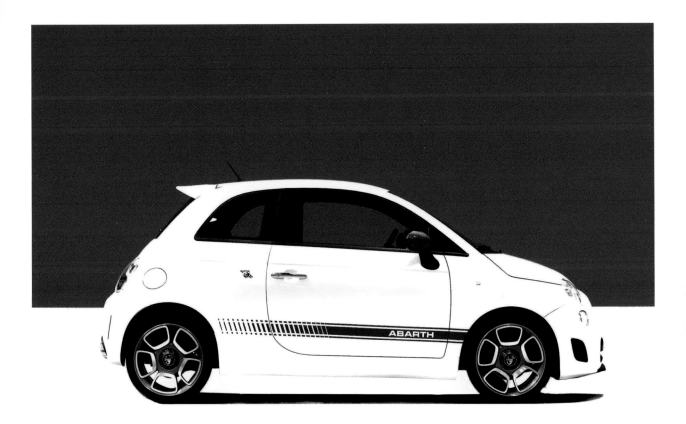

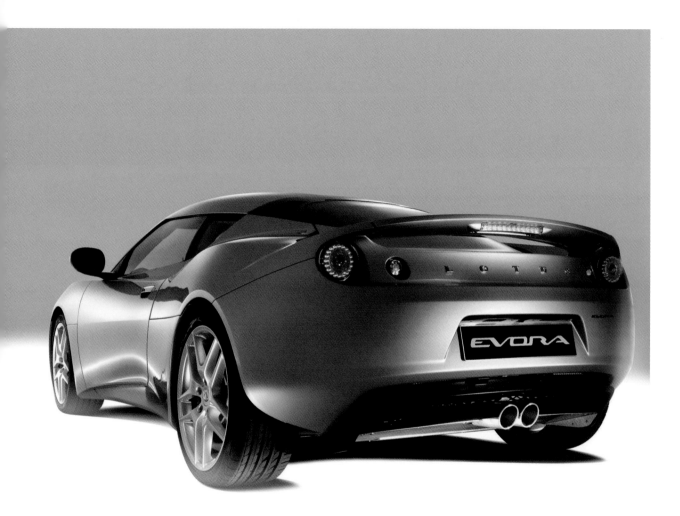

Lotus Evora

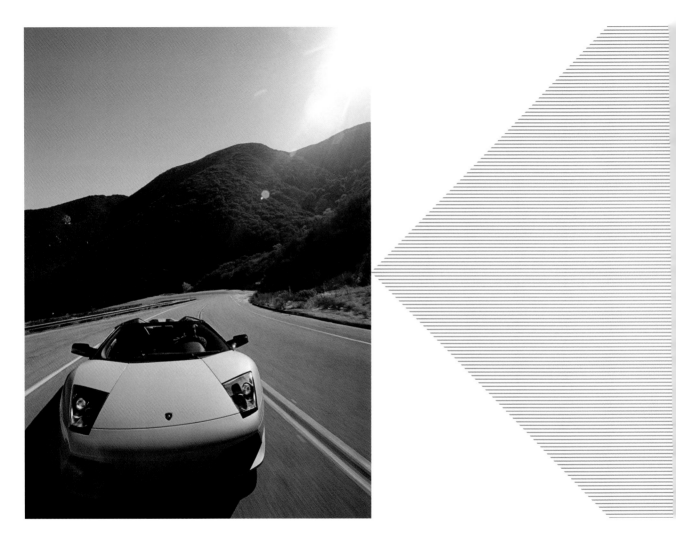

Lamborghini Murciélago LP640 Roadster

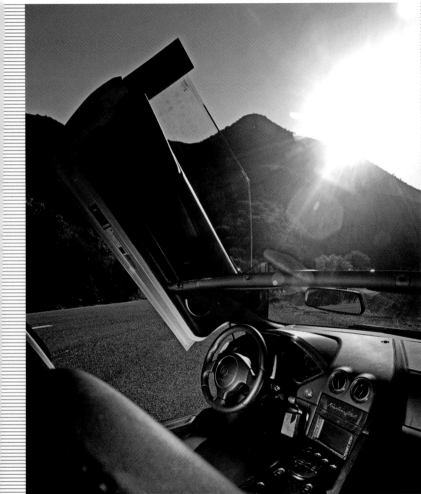

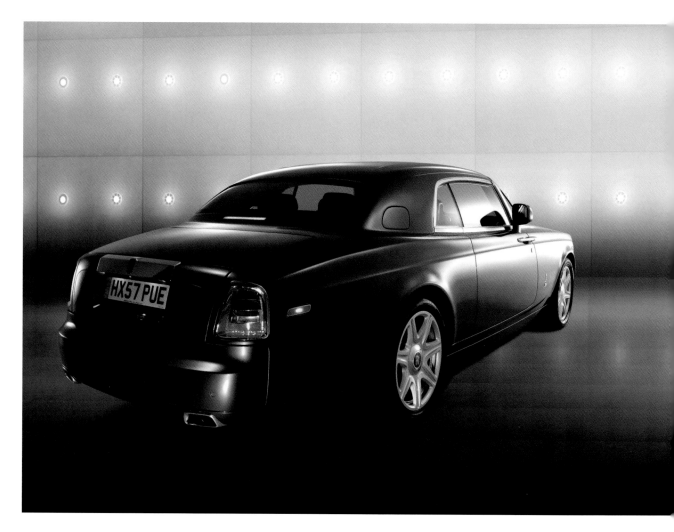

Rolls-Royce Phantom Coupé

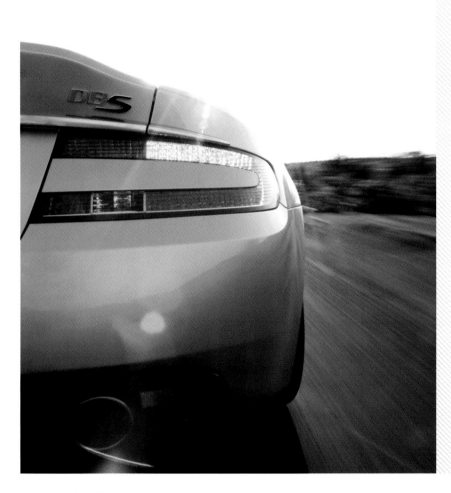

Aston Martin DBS

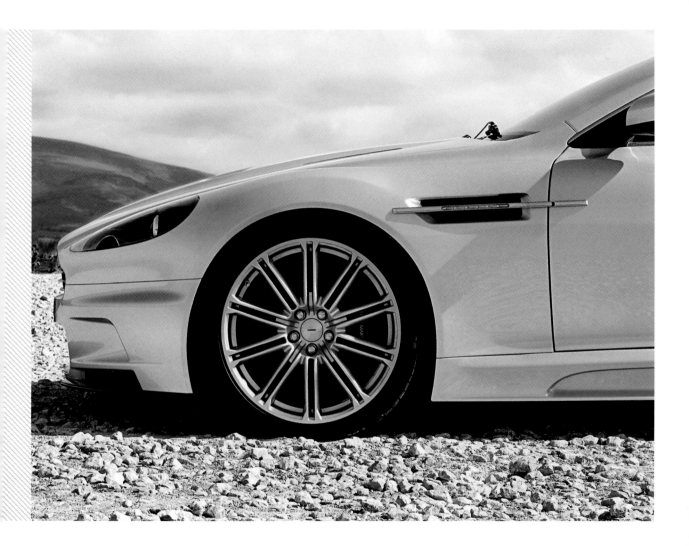

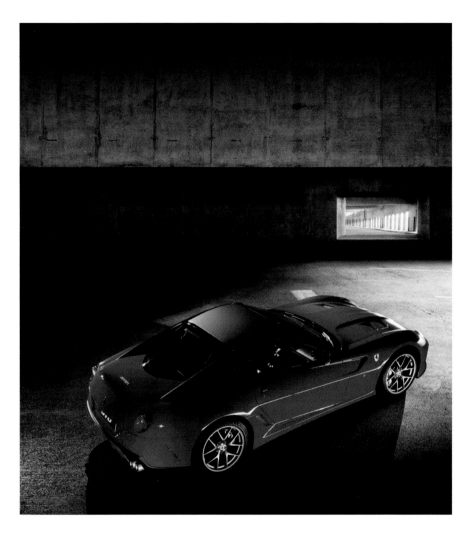

Ferrari 599 GTO

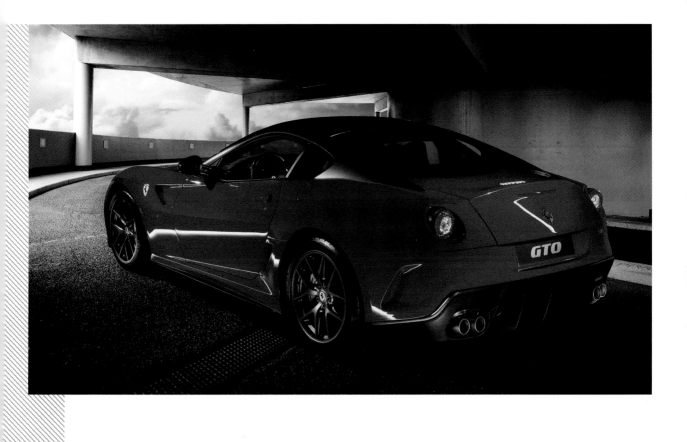

Index

/43

Ford GT

Right at home – the 212mph Ford GT pictured on the streets
of Detroit. This 550bhp, 5.4-litre V8 update of Ford's sixties
Le Mans classic was suddenly famous all over again

Tom Salt

/44

Aston Martin One-77

The name has a certain airliner ring to it
but the car is a future Aston Martin classic

David Riley

/45

Mercedes-Benz SL 65 AMG Black

If it's true that power corrupts, then this has to be the most
sinful, degenerate and wicked thing on four wheels. Which it
sort of is, but my God, vice has never been so nice

John Wycherley

/46

Caterham R500

The latest evolution of Caterham's fire-breathing R500
Superlight (with 520bhp-per-tonne on tap)

James Lipman

/48

Dodge Viper

The 600bhp, 8.0-litre, V10 Viper – only in America

Lee Brimble

/49

Audi R8 V12 TDI

Audi made it work at Le Mans and they made it work in a
road car. Who would have thought it, one of the greatest
sportscars on the road today is powered by a diesel engine

Justin Leighton

/50

Rolls-Royce Phantom Drophead

A stately and serene convertible Roller sits quietly among
the frenetic hubbub of Tokyo's oldest district

Lee Brimble

/52

Chevrolet Camaro

As American as it gets – a hot Chevy parked
outside a 'tire and wheel' shop

Anton Watts

/53

Aston Martin Rapide

Long-legged and luxurious, is this the
definitive British grand tourer?

Justin Leighton

/54

Bentley GTZ Zagato

As rare as it gets (only nine have ever been built) and
expensive with it – £850,000 – which makes more sense if you
know that the rear lights cost around a tenth of the total!

Parabolique

/196
Hennessey Venom GT
This makes no sense at all, but somehow works.
A 1,000bhp Amercian V8 lump shoehorned
into a svelte Lotus Exige frame. Wow...
Joe Windsor-Williams

/197
Mercedes-Benz SLR McLaren 722 GT
Sure, this special edition Mercedes-Benz McLaren is a nod
towards a famous Mille Miglia car driven by Stirling Moss but it's
also a lighter, faster £700,000 version of the 'ordinary' McMerc
Ripley & Ripley

/198
Bentley Azure
The epitome of a Bentley – a big,
two-door, four-seater convertible
Joe Windsor-Williams

/200
McLaren F1
This is what happens when a race-car constructor
uses all that it knows and makes no compromise.
A genuine, everlasting classic
Lee Brimble

/202
Ferrari 458 Italia
A beautiful image of one of the all-time great Ferraris
(and *Top Gear*'s car of the year in 2010)
Justin Leighton

/204
Porsche Cayman S
Mid-engined – not rear-engined – and (according to some)
a car that Porsche has engineered to be just a touch
less capable than its iconic 911. But just a touch
Lee Brimble

/206
KTM X-Bow
You know the kind of cars you draw when you're a teenager?
KTM built one and it's unbelievable fun to drive
Lee Brimble

/207
Porsche 918 Spyder
Trust Porsche to be thinking already about the future of the
supercar. It may be a 'hybrid' but it still looks like a Porsche
David Riley

/208
Ariel Atom V8
This is the one with the V8 engine and a sequential gearbox,
giving this Atom a power-to-weight ratio almost twice that of
a Bugatti Veyron. Speed is measured in warp factors
Ripley & Ripley

/210
Fiat 500 Abarth
160bhp from a 1.4-litre turbo and that exquisite
styling and history. What more do you need?
Alex Puczyniec

5 7 9 10 8 6 4

Published in 2011 by BBC Books, an imprint of Ebury Publishing.
A Random House Group Company

The Random House Group Limited Reg. No. 954009

Addresses for companies within the Random House Group can be found at
www.randomhouse.co.uk

A CIP catalogue record for this book is available from the British Library.

ISBN 978 1 849 90298 4

The Random House Group Limited supports The Forest Stewardship Council®(FSC®), the leading international
forest-certification organisation. Our books carrying the FSC label are printed on FSC®-certified paper. FSC
is the only forest-certification scheme supported by the leading environmental organisations, including
Greenpeace. Our paper procurement policy can be found at www.randomhouse.co.uk/environment

Commissioning Editor Lorna Russell
Editor Caroline McArthur
Pictures & captioning Garry Martin / Method UK
Design & layout David Pitt / Method UK
Introduction Matt Masters

Printed and bound in China by C&C Offset Printing Co., Ltd

To buy books by your favourite authors and register for offers, visit www.randomhouse.co.uk

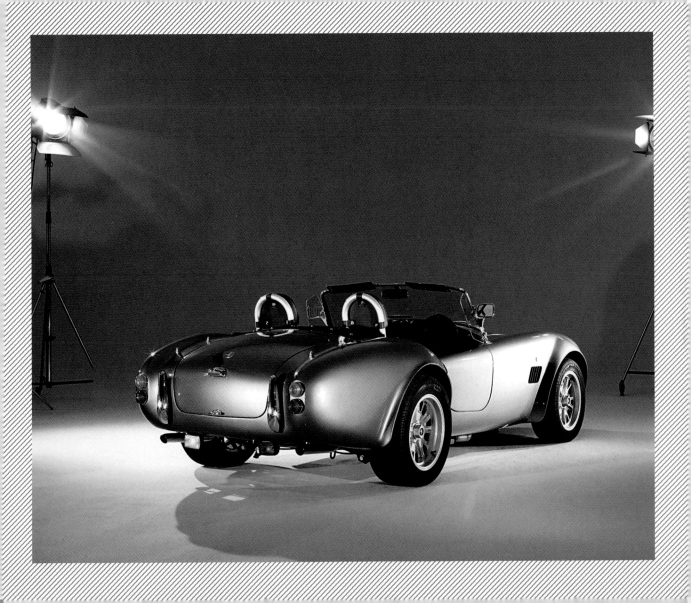

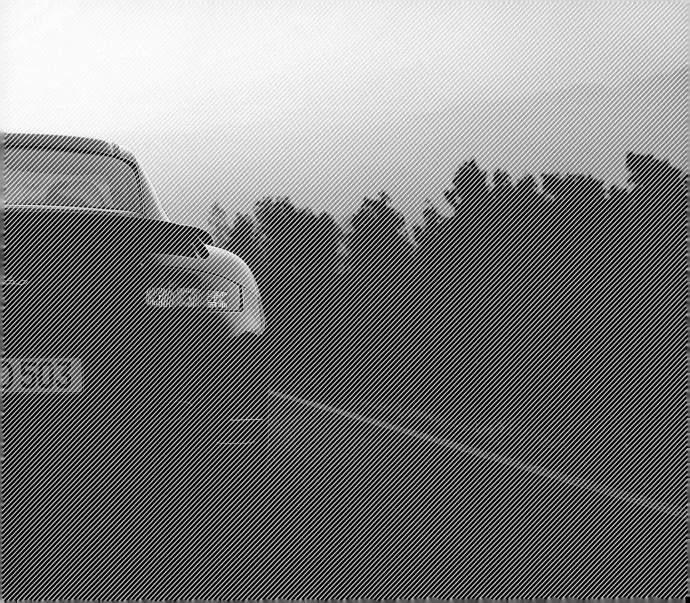